Sister and I in Alaska

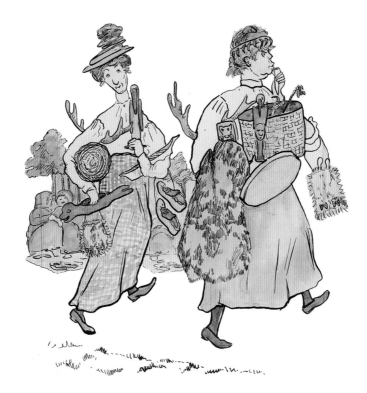

An Illustrated Diary of a Trip to
Alert Bay, Skagway, Juneau, and Sitka in 1907

With the full typescript and illustrations of some pages of a letter concerning a visit to Alice Carr by Tom Daly in 1947, during which the diary was read aloud.

EMILY CARR

Sister and I in Alaska

Figure.1
Vancouver / Berkeley

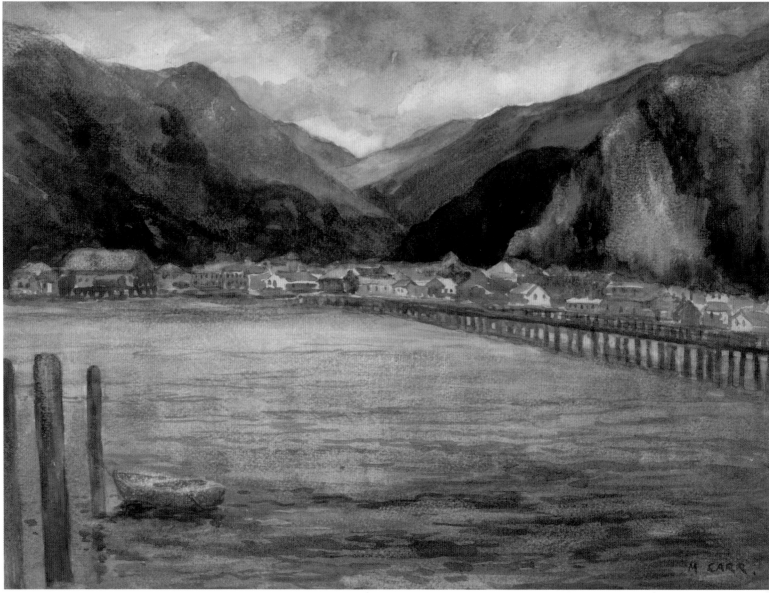

FIG. 1

Introduction

DAVID P. SILCOX

WHEN EMILY CARR, with her sister Alice, embarked on the SS *Princess Royal* bound for Alaska on August 18, 1907, it was with the idea that it would be a holiday adventure. She little expected to look back on the trip as a critical turning point in her life and her art. Carr was nearly thirty-six years old when they set off, yet she still had been unable to find her own style as an artist. Diligent and ambitious she may have been, but she did not have a clear mission in life. Her father's financial success had given her and her five siblings a comfortable middle-class upbringing, but that did not help focus Carr's resolve to be an original artist. This trip to Alaska, miraculously, did begin to transform her. Neither San Francisco nor London, she would later write, gave her what the Pacific Coast landscape and the art of the Northwest Coast tribal peoples did.

Her epiphany, such as it was, happened in Sitka, a port city on Baranof Island in the Alaska Panhandle, where the *Princess Royal* arrived from Skagway at six in the morning. After checking into their hotel, the Carr sisters walked along the main street and met "our old Skagwayan friend, 'La totem,'" whom Carr never names.

> We were immediately adopted, and straightway taken for our initaition [*sic*] trip to the totem poles, and thereafter bourn [*sic*] thither twice daily, for the rest of our sojourn in Sitka, be the climatic conditions favourable or unfavourable. ¹

Since Emily and Alice were in Sitka for about a week, this seems quite a vigorous regime. According to her later accounts, Carr was both appalled and enchanted by what she saw. Just a year or so earlier, a group of totem poles had been an exotic attraction at several major fairs in the lower states (Missouri, California, and Washington). Subsequently, the mayor of Sitka had installed the

EMILY'S SISTER ALICE

collection as a "totem walk" along a path among the trees in a public park. Carr was appalled, in retrospect, by the fact that the totems had been yanked out of their traditional context as Indian village markers or house posts and set up as a tawdry tourist display. Yet she was enchanted by their impressive size and the intricacy, boldness, and power they conveyed, even when stripped away from their original settings. Although her later friendliness with many of the Haida, Gitxsan, Tlingit, and Tsimshian people, among other groups, meant Carr was familiar with their blankets, bracelets, rattles, bowls, bent boxes, spirit catchers, and masks, her focus as an artist remained only on the totem poles, the house posts, the fanned-out shoreline villages, and the decorated canoes.

Another event in Sitka made a profound change in Carr, one she recalled many years later in *Growing Pains*:

> As we walked through the little town of Sitka I saw on a door, "Picture Exhibition—Walk In." We did so.

2

The studio was that of an American artist who summered in Sitka and wintered in New York where he sold his summer's sketches, drab little scenes which might have been painted in any place in the world. He did occasionally stick in a totem pole but only occasionally as a cook sticks a cherry on the top of a cake.

The Indian totem pole is not easy to draw. Some of them are very high, they are elaborately carved, deep symbolical carving, as much or more attention paid to the attributes of the creature as to its form.

The Indian used distortion, sometimes to fill spaces but mostly for more powerful expressing than would have been possible had he depicted actualities—gaining strength, weight, power by accumulation.

These totem figures represented supernatural as well as natural beings, mythological monsters, the human and animal figures making "strong talk," bragging of their real or imagined exploits. Totems were less valued for their workmanship than for their "talk."

The Indian's language was unwritten: his family's history was handed down by means of carvings and totemic emblems painted on his things. Some totems were personal, some belonged to the whole clan.

The American artist found me sketching in the Indian village at Sitka. He looked over my shoulder; I squirmed with embarrassment. He was twice my age and had had vastly more experience.

He said, "I wish I had painted that. It has the true Indian flavour."

The American's praise astounded me, set me thinking.

We passed many Indian villages on our way down the coast. The Indian people and their Art touched me deeply. Perhaps that was what had given my sketch the "Indian flavour." By the time I reached home my mind was made up. I was going to picture totem poles in their own village settings, as complete a collection of them as I could.

This was an ambitious goal, and it was probably sparked in part by the view, prevalent at the time, that the indigenous population of Canada was petering out and would soon be gone. A.Y. Jackson, Lawren Harris, Marius Barbeau, and

others certainly said so. Jackson believed the same to be true of the French Canadian villages along the St. Lawrence River, which he painted to document them before they disappeared. Similarly, Carr would document the Northwest Coast Indian villages before they became relics. Since communities such as the Haida had already suffered a catastrophic loss of nine-tenths of their population due to smallpox, the outlawing of traditional practices like the potlatch, and the experience of being dislodged, absorbed, and pushed rudely to the margins of the society that was replacing them, one can understand why the idea of sharp decline and eventual demise was then so believable.

With the work of Paul Kane and the American George Catlin committed earlier to the same proposition, Carr had a strong nudge from current thinking and tradition. Hindsight can cast a rosy haze over the past, and Carr, writing in the late 1930s and the early 1940s, did not remember the reason for her resolve as accurately as she might have intended.

The "American" who accidentally lit the long-smouldering fuse that finally ignited the Emily Carr we know today was initially identified as Theodore Richardson, an artist who painted at Sitka and lived in Minnesota and then California. Richardson didn't winter in New York, though, or sell his paintings there. A close study of Carr's Alaska trip, "Reconstructing Emily Carr in Alaska," was undertaken by Jay Stewart and Peter Macnair in 2006 as part of the major National Gallery of Canada/Vancouver Art Gallery Emily Carr exhibition. In their fine essay, which provides a history of Sitka and describes the extensive tourist traffic of the time, they cite the sailing times and schedules of the various ships that Carr and her sister took, in order to identify which Indian villages they might have seen or visited. Finally, they compare Carr's work then with the work of others.

Stewart and Macnair propose that James Everett Stuart was "a more likely candidate to have been Carr's [artistic] mentor," and they offer convincing evidence to support this. Stuart did have a studio in New York, he was much less accomplished a painter than Richardson (hence Carr's reference to his "drab little scenes"), and he punctiliously dated his work each day. Stuart was, perhaps, a man whose praise could have affected Carr more than his example as a painter. However, after tracing both men's itineraries, Stewart and Macnair conclude "there is no primary evidence" that either of them was in Sitka when Carr was there.

Carr had grown up with the West Coast Indian presence and seen totem poles since she was a child. Her affinity for the native people was evident early on. In 1899, when she was still in her twenties, she had gone to Ucluelet, a remote Indian community on the west coast of Vancouver Island, where she painted the people and their village and was given the name Klee Wyck–Laughing One.

Still, Carr had taken a very long time to get to the critical point in her life that the trip to Alaska represented. For two years (1891–93), she had trained at the California School of Design in San Francisco. From 1899 to 1904 she was in England, where she attended the Westminster School of Art in London, then studied in St Ives, where she could paint out of doors, and at Meadows Studio in Bushey, just outside London. These were all rather frustrating experiences, despite a pleasant holiday in Scotland and a 1901 Easter jaunt across the Channel to Paris for twelve days. Her thorough dislike of London, along with some serious health problems, made this period of her life a largely unproductive one. Her protracted formative years may have contributed to the exasperation her family expressed about Carr's determination to be an artist–in addition to their lack of comprehension for her work when she finally showed her true colours.

Other factors that throw doubt on Carr's retrospective view are the state of her painting in 1907 and the fact that the only native villages their ships docked at, or even came close to, were Alert Bay, to which she returned in 1908, and Sitka. The "many Indian villages" she supposedly saw on their trip back from Alaska, she did not actually see until 1912. Carr's paintings from both 1907 and 1908 are still heavily freighted with her extensive art school experiences in California and England. Although pretty and not without merit, they lack decision, focus, and lucidity. And like Tom Thomson's work before 1913, they give little indication of what was about to emerge. Her 1907 watercolours, which she titled *Skagway from End of Wharf–Cold Wind–Ugh!* (fig. 1) and *Sitka, at the Bakery and Shops of the Russians–Later Sitka Trading Co. Building* (fig. 2), show her commendable proficiency in the English Victorian watercolour tradition. The most striking thing about them is the complete absence of the modernist idiom that was to give life and energy to her paintings of subjects in British Columbia in 1912 and after.

Even after 1907, when Carr claimed she knew with some conviction what she was going to do as an artist, she was still five years away from discovering the

visual grammar and vocabulary she needed and could call her own. She spent 1908 and 1909 in Vancouver, trying to paint and to teach painting. She returned to Alert Bay in 1908 on a painting trip. In 1910 and 1911 she went to France, where she had an introduction to Harry Gibb, a modern painter. Gibb's work made bold use of bright colours as they were then being exploited by les Fauves in southern France and Paris. Gibb advised Carr to enroll in the Académie Colarossi in Paris, where she lasted a short three months. Nor was she as pleased with Paris itself as she had been a decade earlier. She followed Gibb to Crécy-en-Brie, a country village about two hours east of Paris near Meaux, and then to Brittany. There she studied further with Frances Hodgkins, a New Zealand painter who taught watercolour painting at Concarneau, a favourite spot for painters like the Canadians J.W. Morrice and Clarence Gagnon, the influential American painter Robert Henri, and many others.

This two-year sojourn in France gave Carr the last and essential ingredients that completed her long apprenticeship. With them, she found a new way of painting that energized and transformed her. Carr's Alaska trip in 1907 was in some respects a visit to a West-Coast Eden—the planting of a seed that germinated, five years later, after the nurturing sunshine and brilliant air of France. In France, Carr discovered how to convey to the viewer the acute and subtle qualities of clarity and light: her paintings lit up physically and seemed bathed in sunshine. She learned how to be direct and plain, how to compose with more simplicity and emphasis. When Carr returned to Canada late in 1911, she was ready to embark on her life's great ambition in earnest. She was able, at last, to marry a style marked by luminosity and crystal clearness with a subject matter that had mystery, exotic novelty, and sophisticated raw power.

EMILY AND ALICE had a wonderful time in Alaska. To commemorate the journey, Carr commandeered a hundred-page unlined scribbler with a deep burgundy cover ("Mapping Book" is embossed on the front cover, and fine double lines frame each page) and made a diary of the trip. She titled it on a strip of tape glued to the top of the front cover: *Sister and I in Alaska*. She wrote on the left-hand pages about incidents along the way, troubles encountered, people met, accommodations endured, weather fair or foul (more often foul), side trips undertaken,

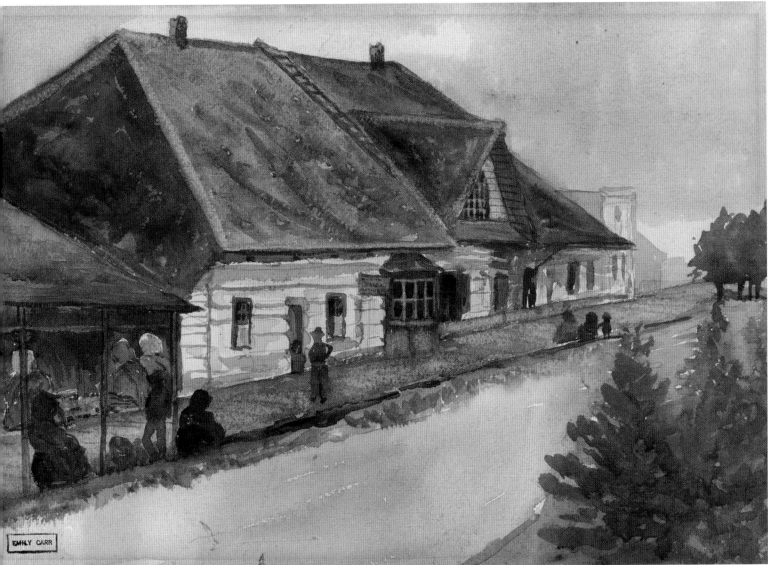

FIG. 2

mountains climbed, paths followed, and sights enjoyed. On the right-hand pages she painted and drew illustrations—cartoons, some have called them—of these events, done with her remarkably keen ability to render a scene with strong composition, in perfect scale and vivid colour, and in watercolour, that most unforgiving of mediums. This was the sort of work she had the ability to do when called upon by local newspapers, magazines, or newsletters. As if to make the point that this diary was in that genre of work, she signed every illustration with her illustrator's *nom de plume* Spudz, a sobriquet she used for herself at the time. Her lengthy training as an artist had been particularly strong in the tradition of English watercolour painting, which is what made her illustrations so sure, definitive, and realistic. The same sureness and originality are displayed in the diary, this first sustained effort to get writing and illustrating working together. The combination is effective and amusing, and it creates an air of immediacy. The model it provides became a hallmark of Carr's way of presenting herself.

The Alaska diary is full of humour and delight, such as the description of how Alice and Emily "medically prepared" themselves with a flask of brandy each to combat seasickness when their ship left the calm Inside Passage for the open Pacific. She rails against the sagging bedsprings of the bunks they tried to sleep in, and she devotes several pages to their jaunt on the White Pass & Yukon Route Railroad, which still runs from Skagway to Whitehorse, and which they took as far as the summit at White Pass. In many illustrations, Carr depicts herself as grumpy and acerbic; her splenetic aggravation with so many things and events and people shows frequently in the diary entries. The red-haired Alice is less bluntly caricatured, portrayed as tall and unflappable, comporting herself with gentle but lofty poise. Carr often made up words, as well as being what one might charitably call a "creative" speller. In Ketchikan, for example, she "overcame the 'peppermint habbit' to which [she] had been edicted since early youth." Her syntax is also original, and at times a reader might imagine that she could have become, with enough application, a strong poet or novelist. Notwithstanding the hurdles to becoming a literary artist, Carr's writing became a major outlet for her expression in later years, when painting was physically too difficult. As in her paintings, she shows in her writing the compelling energy of someone who

is never satisfied. Carr was deeply infected by that divine discontent that drives major artists in all disciplines.

Carr's 1907 Alaska diary set a pattern for her later writing. Three years later, in 1910, Alice and Emily left Victoria for London, and then France. Using another scribbler, Carr wrote and illustrated a diary of their trip across Canada to Quebec City, then across the Atlantic to Liverpool and thence to London. This diary, *Sister and I from Victoria to London*, was published in 2011 as a fully illustrated edition with an extensive foreword by Kathryn Bridge, complete with photographs and postcards, and even a glossary to translate Carr's atrocious spelling. The publisher, the Royal British Columbia Museum in Victoria, reprinted it in 2012.

Carr's idea of a narrative was a series of small, isolated anecdotes, vividly described. A linear, chronological story was either not in her character or simply not the imaginative way she chose to portray her experiences, emotions, or thoughts. She much preferred, it seems, to set up verbal tableaux—brief, intense pictures that were charged with descriptive meaning and feeling. Much of her writing, done during her sixties and early seventies (she died at seventy-three at the beginning of March 1945) follows the format she used in the Alaska diary, amplified somewhat in the *Victoria to London* diary. The pattern is evident in *Klee Wyck*, her first work, published in 1941 and the winner that year of the Governor General's Award for Literary Merit (non-fiction), and in *The Book of Small* and *The House of All Sorts*, published in 1942 and 1944 respectively. Her other major writings—*Growing Pains: The Autobiography of Emily Carr* and *Hundreds and Thousands: The Journals of Emily Carr*—were published posthumously in 1946 and 1966 respectively, compiled and edited from Carr's manuscripts and notes to replicate the pattern she had found so congenial.

SISTER AND I IN ALASKA was given to Alice and thus was not part of the literary contents of the large trunk that served Carr for more than half a century during her travels from Victoria to San Francisco, Alaska, across Canada, and twice to Europe and back. Filled with papers, letters, sketchbooks, and other things, Carr's trunk was entrusted to Ira Dilworth, her literary editor. Some of its contents were disbursed among Dilworth's heirs when he died in 1962, and much of

that material ended up in the Royal British Columbia Museum in the late 1980s, including the manuscript for *Sister and I from Victoria to London*, which Alice had felt ought also to belong to her. In her foreword to the published Victoria to London diary, Kathryn Bridge wrote:

> This was not Carr's first "funny book." She employed the same format in an earlier vacation journal, in 1907, when she and Alice headed north to Juneau and Skagway, Alaska. In this journal she also wrote on the left-hand pages and painted watercolour illustrations on the right-hand pages. Unfortunately, all that remains of her "Alaska Journal" are black-and-white photographs of six pages. The original, last seen in the 1950s, has vanished.

Fortunately, the long-lost diary of 1907 has now reappeared. Alice Carr had inscribed it *Happy New Year 1953, To Katherine and Arthur, with Alice's love,* and sent it by registered mail to Katherine and Arthur Daly in Toronto. Katherine Daly had written a "fan" letter to Emily in January 1945. To her surprise, Carr replied. A correspondence began to flow, but was cut short by Carr's death early in March. Alice wrote to Katherine about the death of her sister and continued a correspondence with her. One of the concerns Alice had was building a small bridge over a stream in Victoria's Beacon Hill Park as a memorial to Emily, who in her last years was taken there frequently. From the correspondence between Alice and Katherine Daly, it appears likely that the Daly family helped this project to be realized and that, although not explicit, the New Year's gift of the Alaska diary was a thoughtful "thank you" from Alice for this assistance. What may also have kept the link between the Dalys and Alice strong is that all three were related to artists, since Arthur's sister was Kathleen Daly, a distinguished painter married to another important painter, George Pepper. In any case, the relationship was lively enough that when Arthur and Katherine's son Tom was in Victoria on business in 1947, he made a point of visiting Alice. After the deaths of Katherine and Arthur Daly, the diary passed into Tom's possession.

Tom Daly was one of the most prolific and distinguished of the many filmmakers at the National Film Board, working first in Ottawa, beginning in 1940, and then in Montreal for the remainder of his long career. When he died in 2011, I

remembered having catalogued a David Milne painting at his house almost forty years earlier, one I hoped to see again. A little later, through an NFB acquaintance in Montreal, I got Tom Daly Jr.'s telephone number and invited myself for a visit, expecting to see the Milne painting. Although the Milne painting had moved on, we had a most pleasant visit, and then, almost as an afterthought, Tom Jr. brought out *Sister and I in Alaska*. The crucial importance of the diary didn't strike me at first, since I didn't know it was "lost." However, it shortly became clear that this was indeed an important early work by a major artist, and that it should be published.

As part of this discovery of the missing diary, another remarkable document has come to light: a long, delightful letter from Tom Daly to his family in Toronto describing the evening he spent with Alice on September 9, 1947. During his late-night visit, Daly wrote, he read the Alaska diary out loud to Alice and her friend Miss Wilson, the three of them laughing and being regaled by Alice with her recollections of the trip. Daly's letter, which runs to twenty-eight six-and-a-half-by-five-inch pages of Empress Hotel stationery, gives a first-hand description of the house where Carr last lived and worked, and where Alice spent her last days. He describes the layout of the house, the pictures on the walls, the studio where Carr worked, with its collection of ceramics by Klee Wyck, and his late-night walk past the House of All Sorts and the old Carr family home, by then a boarding house. Tom Daly's letter is reproduced in this book following the diary, for the reader's enjoyment.

And so a charming account of a cheerful adventure more than a hundred years ago is here unveiled for readers to savour. Even more important, however, what we have in this lost diary, now rediscovered, is the account by an intrepid Canadian artist of a trip that changed her profoundly.

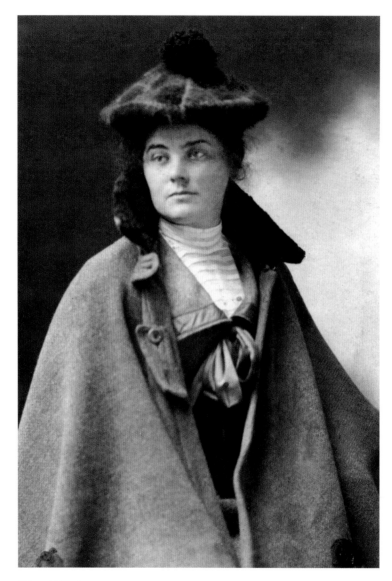

EMILY CARR IN 1901

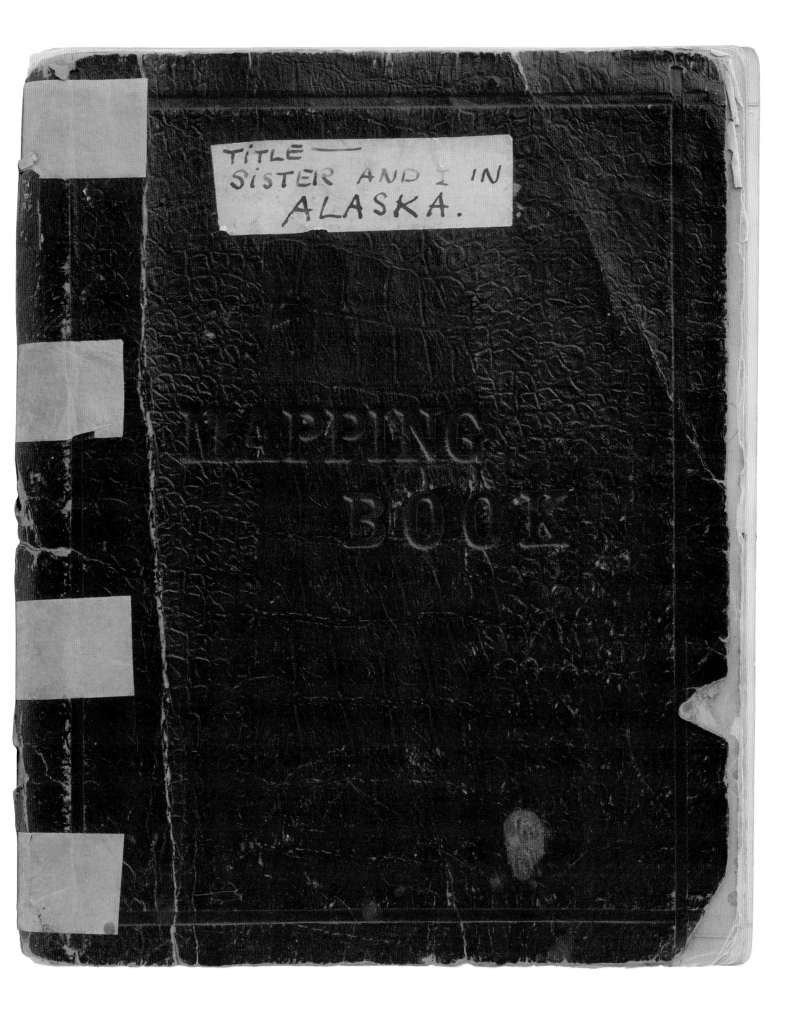

TITLE —
SISTER AND I IN
ALASKA.

MAPPING
BOOK

Sculptor's Notebook

Miss M. Carr
570 Granville St
Vancouver B.C.

by Mr Anderson
Bank BNA Montreal

To the Gentle Sister who shared these
experiences I dedicate this book.

M. Emily Carr

Happy New Year 1953

To Katherine & Arthur

with Alice's love.

On August the 18th 1904. Sister and I
set forth on the S.S. Princess Royal
bound for Alaska and on pleasure bent
She was a good boat save in the matter
of bed springs which proved to be
insufficiently strong for the heavy weights.

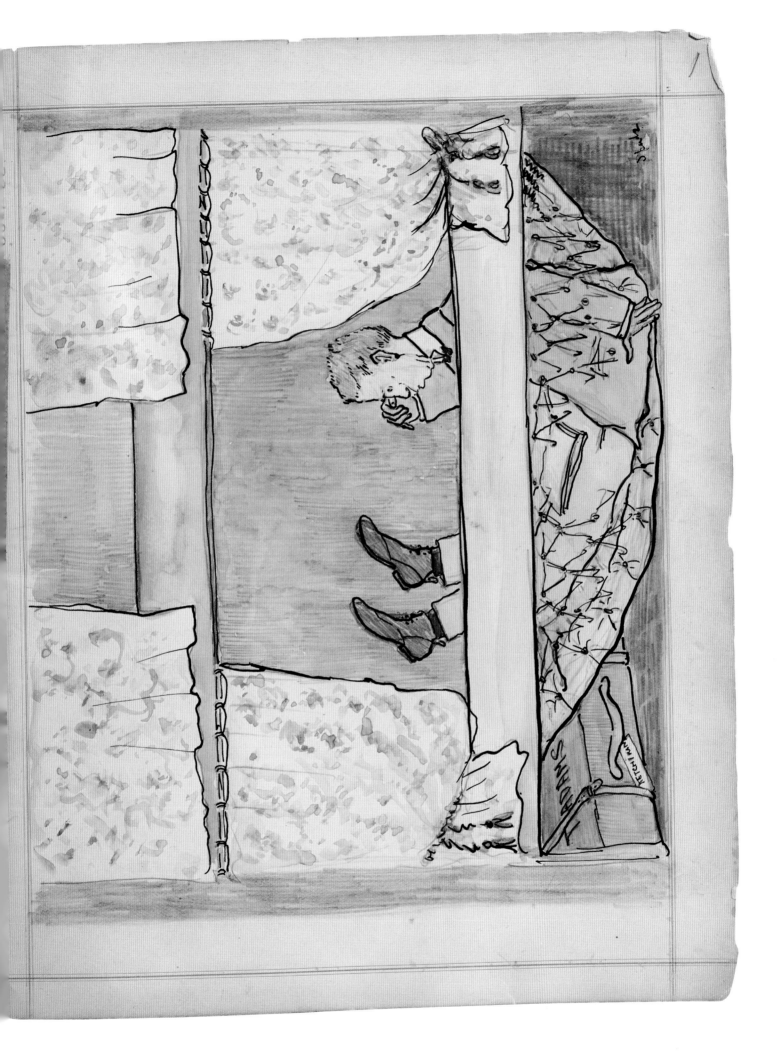

OUR PLEASURE AT MEALTIMES WAS ALSO MUCH

MARRED BY OUR ~~VIS~~-A-VIS.

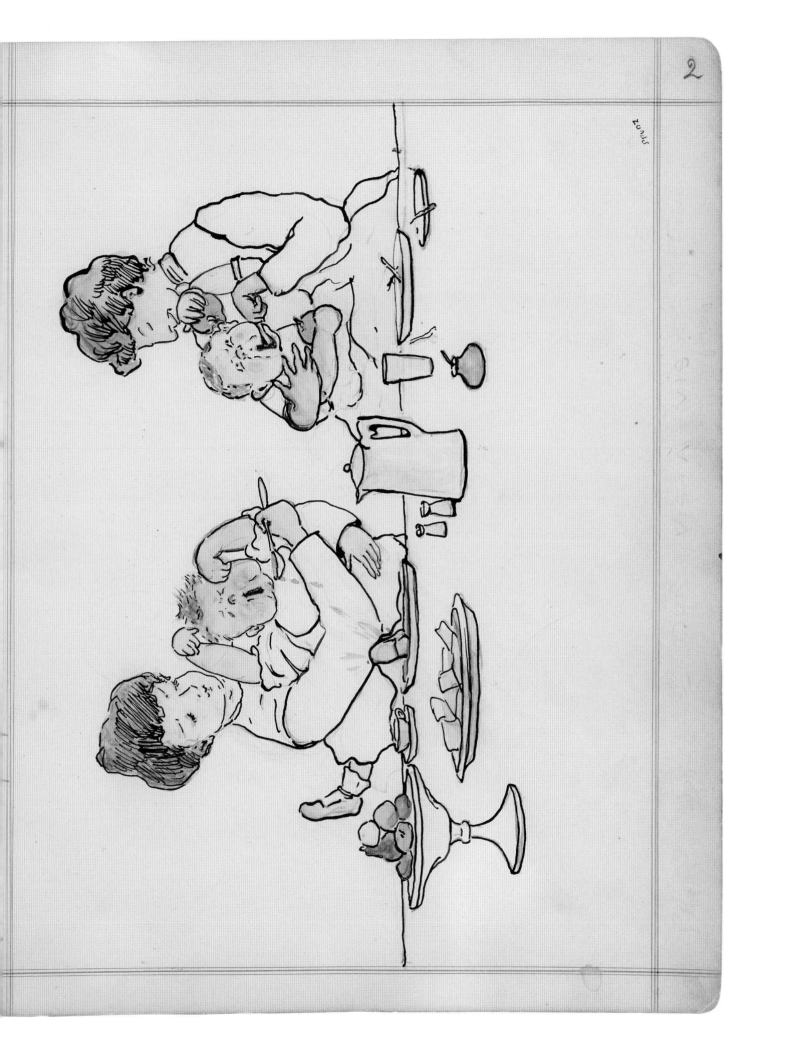

KETCHIKAN WAS THE FIRST IMPORTANT STOP AND HERE I OVERCAME THE "PEPPERMINT HABBIT" TO WHICH I HAD BEEN EDICTED SINCE EARLY YOUTH. KETCHIKAN BEING NOTED FOR A PARTICULARLY FINE BRAND WE PURCHASED A LARGE BAG OF THE LUCIOUS AND SWEET SMELLING DAINTY, AND PARTOOK SO EXTRAVAGANTLY OF THEM DURING OUR WHOLE STAY, THAT I HAVE RECOILED FROM THE TASTE AND ODOUR OF THEM EVER SINCE. SISTER AND MR ~~ADAMS~~ JONES I BELEIVE STILL ENJOY THEM.

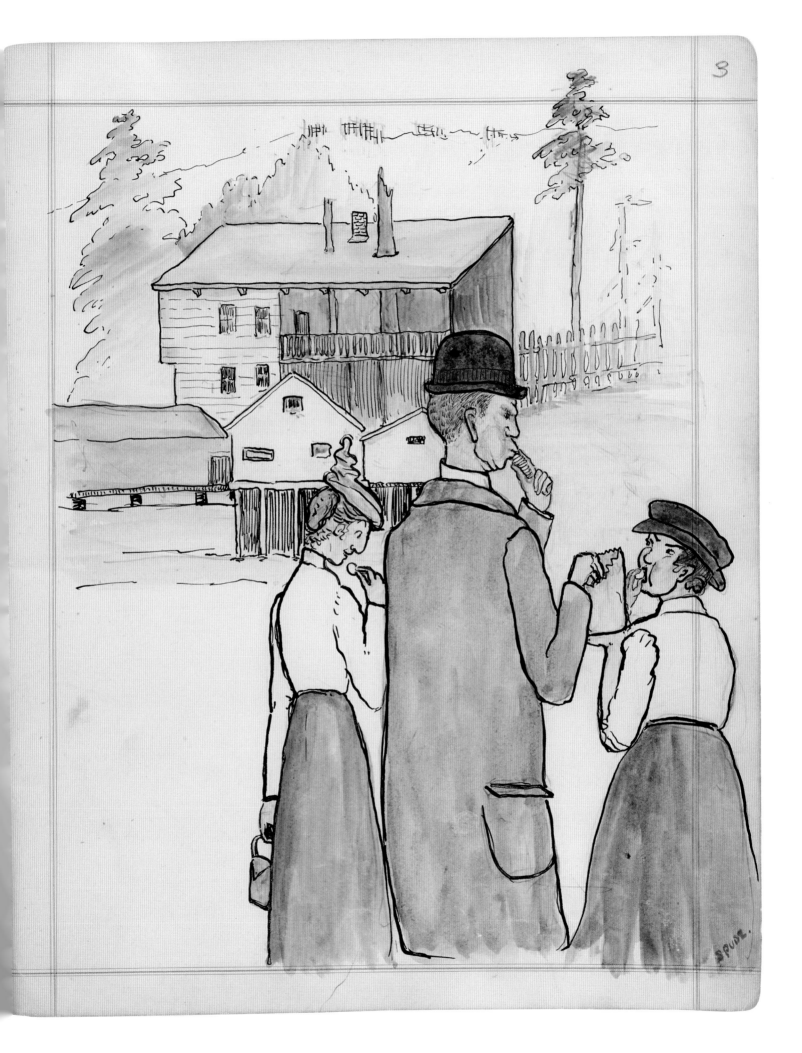

THO' WE PASSED MAINLY THROUGH PLACID CHANNELS,
AMONG THE ISLANDS THERE WERE OCCASIONS
ON WHICH VICIOUS STRIPS OF OPEN SEA HAD TO BE
CROSSED: FOR THESE SISTER AND I WERE
WELL EQUIPPED, AND HEROICALLY PREPARED OURSELVES.

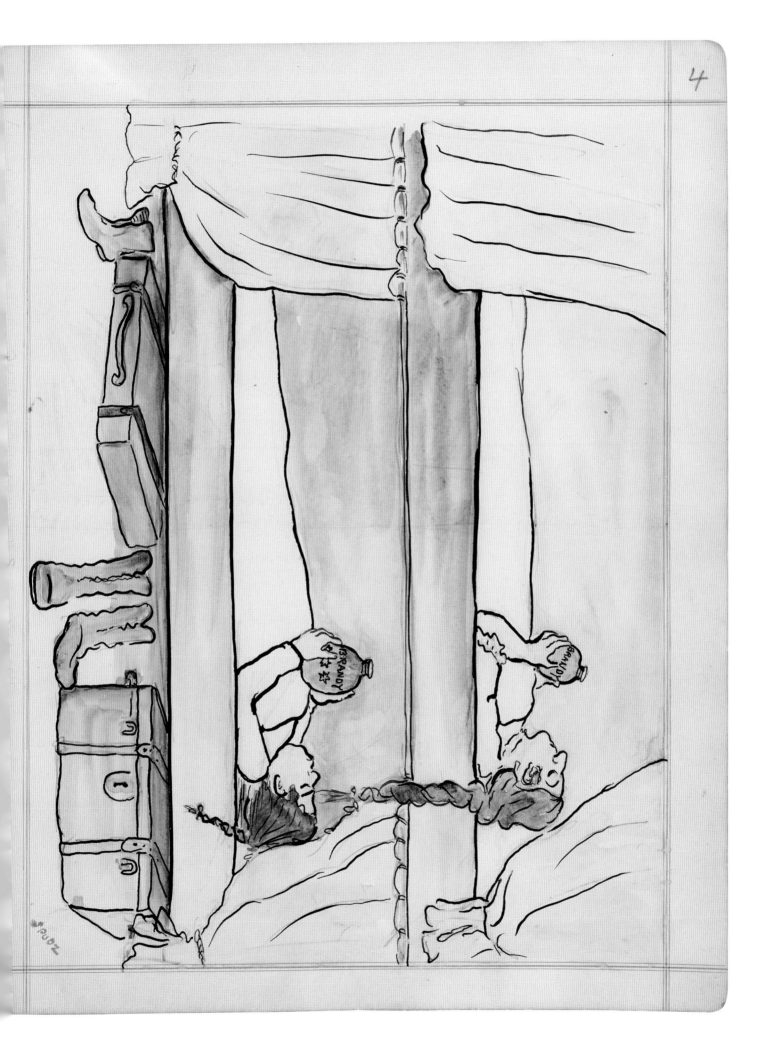

AT PORT ESSINGTON, WE ENCOUNTERED AN ODD FREIND ON THE WHARF, WHO WARMLY RECCOMMENDEO TO US A CERTAIN BOARDINGHOUSE IN SKAGWAY: "THE LADY HE SAID IS CHARMING" "AND POSSESSES TWO COWS; THREE SONS AND A SIDE SADDLE," DAZZLED BY THE ANTICIPATION OF SO LUXURIOUS AN ABODE, AND BEING PARTIAL TO SADDLE EXERCISE, (THERE WAS NO MENTION OF A HORSE) WE ALLOWED OUR IMMAGINATIONS TO SOAR.

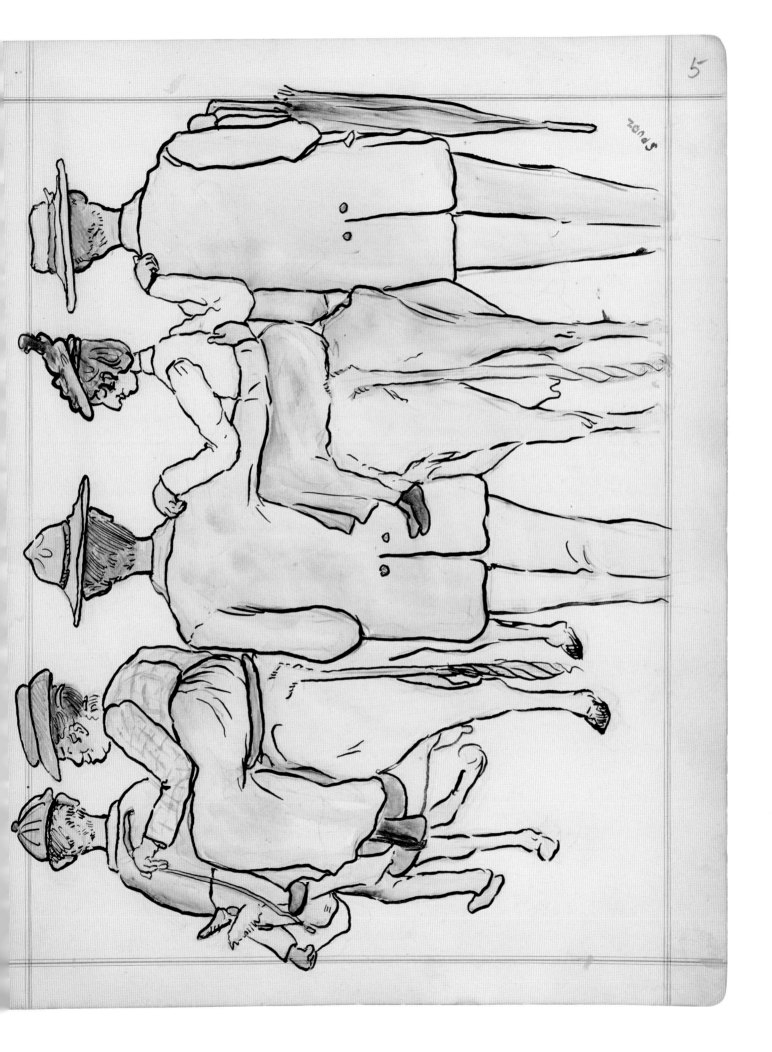

THESE HOWEVER WERE BROUGHT DOWN WITH A
CRUEL BUMP ON OUR ARRIVAL IN SKAGWAY, THE
STALWART SONS BEING ABSENT; (MOSTLY TOURING
WITH FOOT BALL TEAMS) AND THE COWS WHOLLY
ABSORBED IN PRODUCING CREAM AND BUTTUR,
(WHICH CERTAINLY WERE DELICIOUS) AND WE WERE
OBLIGED TO RELY. SOLELY FOR SUPPORT ON OUR
STOUT UMBRELLAS AND FOOT IT.

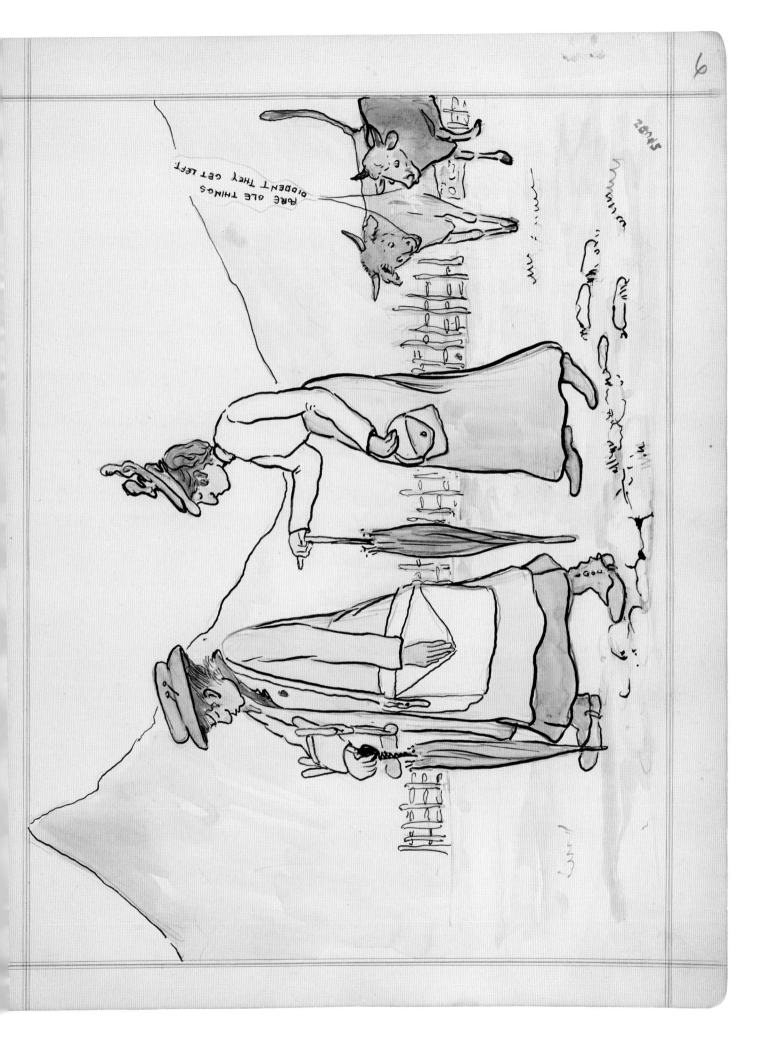

OF COURSE WE TOOK IN THE WHITE PASS TRIP—
EVERYBODY DOES; THE VEIW IS <u>SO</u> MAGNIFICENT! WE
ABSORBED IT FOR FOUR HOURS IN THE SHAPE OF
FLUFFEY WHITE MIST, WHICH SAT WEEZILY ON OUR
CHESTS; WHILE THE HEAVENS POURED RAIN UPON US.
SISTER SELECTED AN EXCEEDINGLY SHARP PINNICLE OF
ROCK, WHOSE PRECIPITIOUS SIDES SHED THE RAIN WELL,
WHILE I CRAULED INTO A HOLE, AND WE PARTOOK OF
LUNCHION. IN DEPRESSED AND CLAMMY SILENCE.

The Summit
White Pass
YUCON TERRITORY
JULY 25 1907

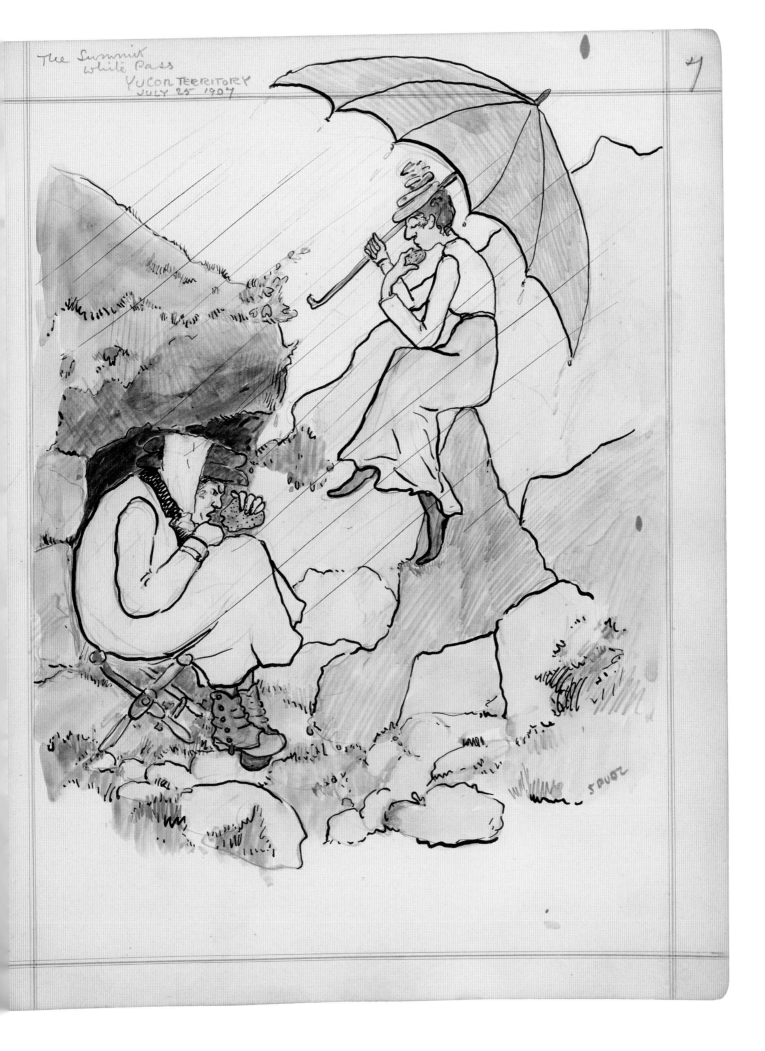

WE RETURNED TO THE STATION IN A BEDRABBLED

AND MELANCHOLY CONDITION, BUT WERE ENABLED TO

PARTIALLY DRY OUR SODDEN GARMENTS. BEFORE THE

TRAIN ARRIAVED. AS IT WAS BELATED.

SISTER REMAINED PLACID AND SWEET THROUGH THE

WHOLE DAY BUT NOT SO SELF. FOR.——

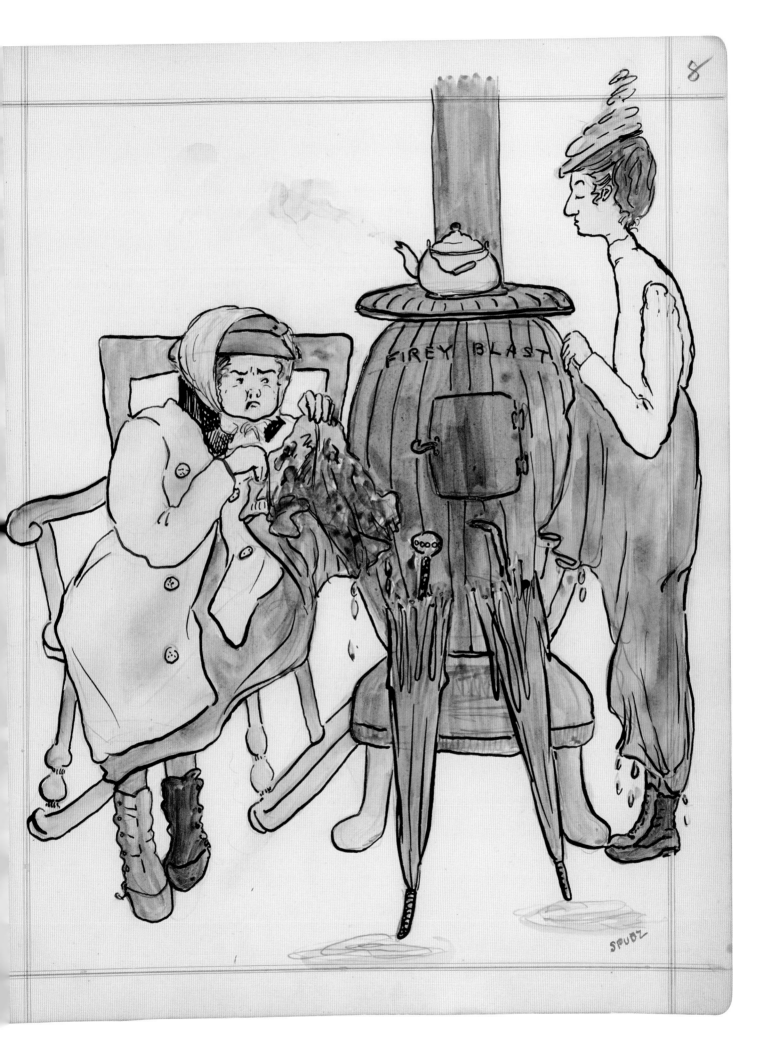

THE ROCKS BEING EXCEEDINGLY SLIPERY, I HAD
FALLEN WITH SUCH VIOLENCE, AS TO CLEFT
THE ROCK UPON WHICH I ALIGHTED, THIS SOWERED
ME FOR THE DAY, THO' SISTER CONTINUED TO
AMBLE AMONG THE ROCKS GATHERING POSIES.
UNRUFFLED AND SERENE. THO' MOIST.

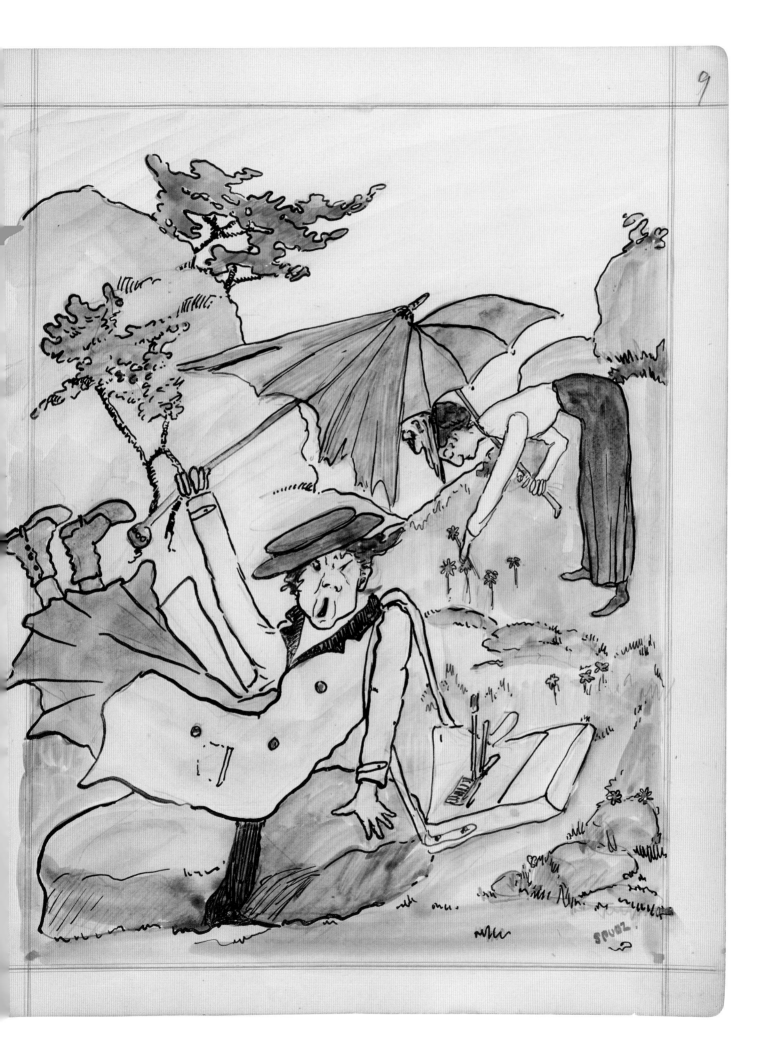

AFTER FIVE DAYS OF PERPETUAL RAIN IN SKAGWAY
LISTLESS DEPRESSION SEIZED US, FOLLOWED BY SEVERE
HOME SICKNESS, AND, CASTING OURSELVES IN TWO ROCKERS
WE ABANDONED OURSELVES FREELY TO GREIF.

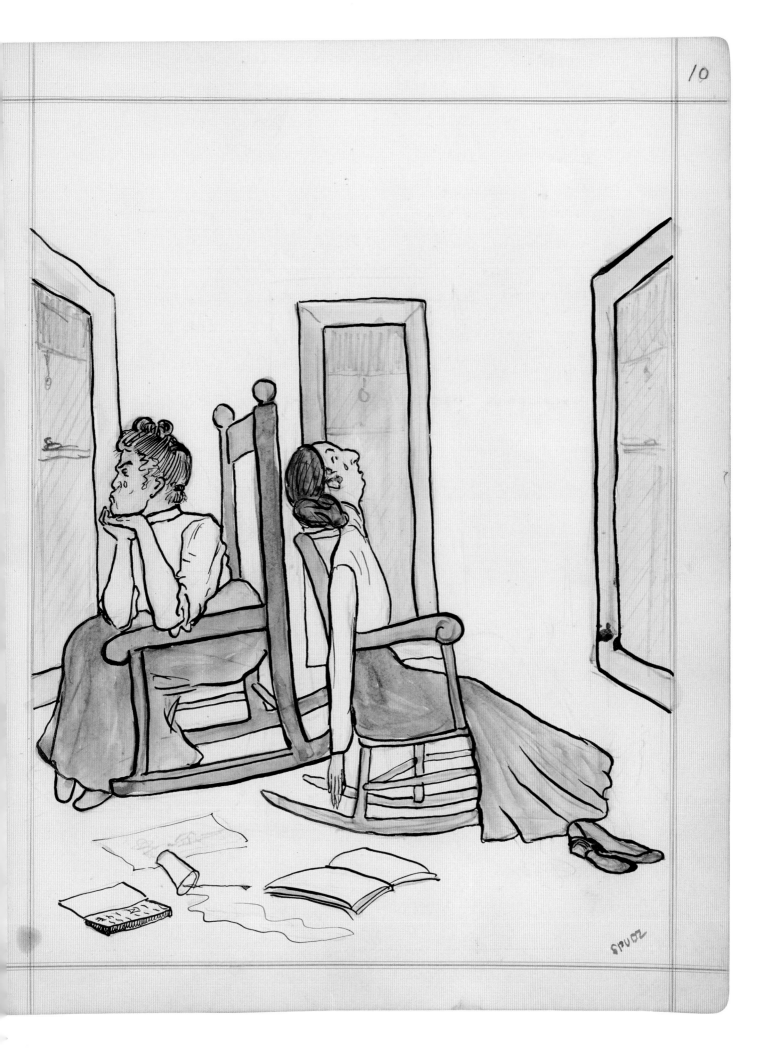

AFTER TEARS HAD BROUGHT RELEIF WE OBSERVED

THE SKY TOO HAD LIGHTENED. SEIZING OUR STOUT

UMBRELLAS; WE PROCEEDED TO CLIMB A HIGH MOUNTAIN.

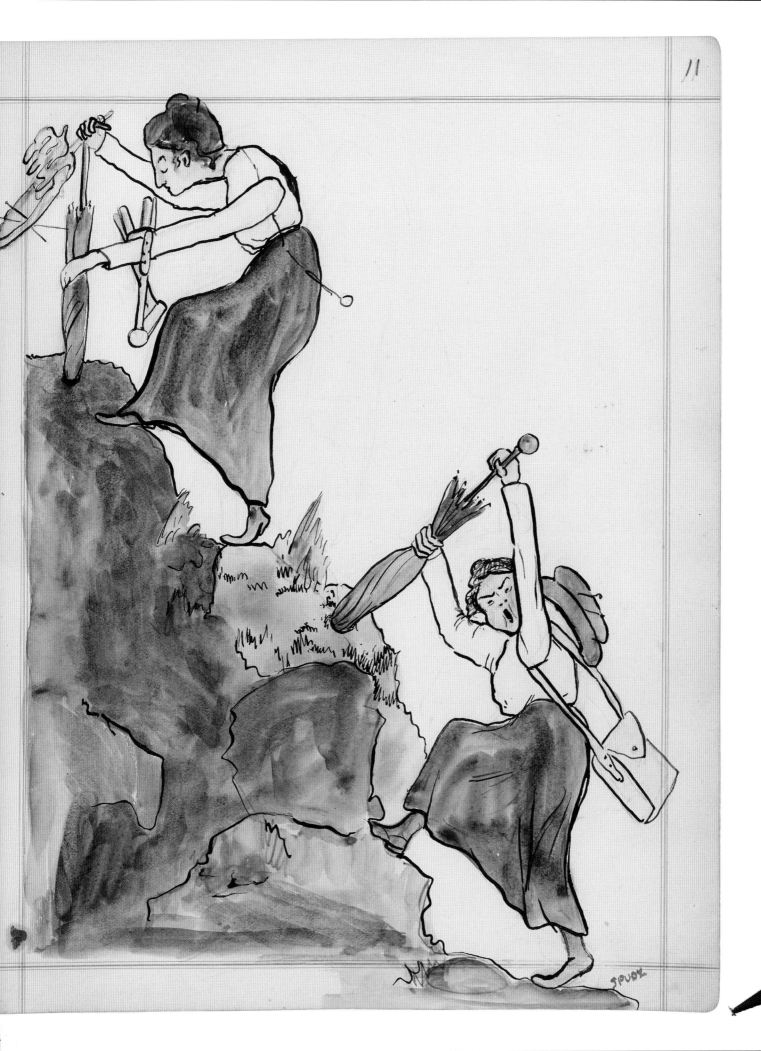

A LAKE WAS ENSHRINED UPON THE MOUNTAIN TOP, AND
HERE WE MET AN OLD MAN, WHO WAS SO
IMPRESSED WITH MY SISTERS RED HAIR AND
GENTLE WAYS, THAT HE TOOK US FOR A ROW IN
HIS BOAT.

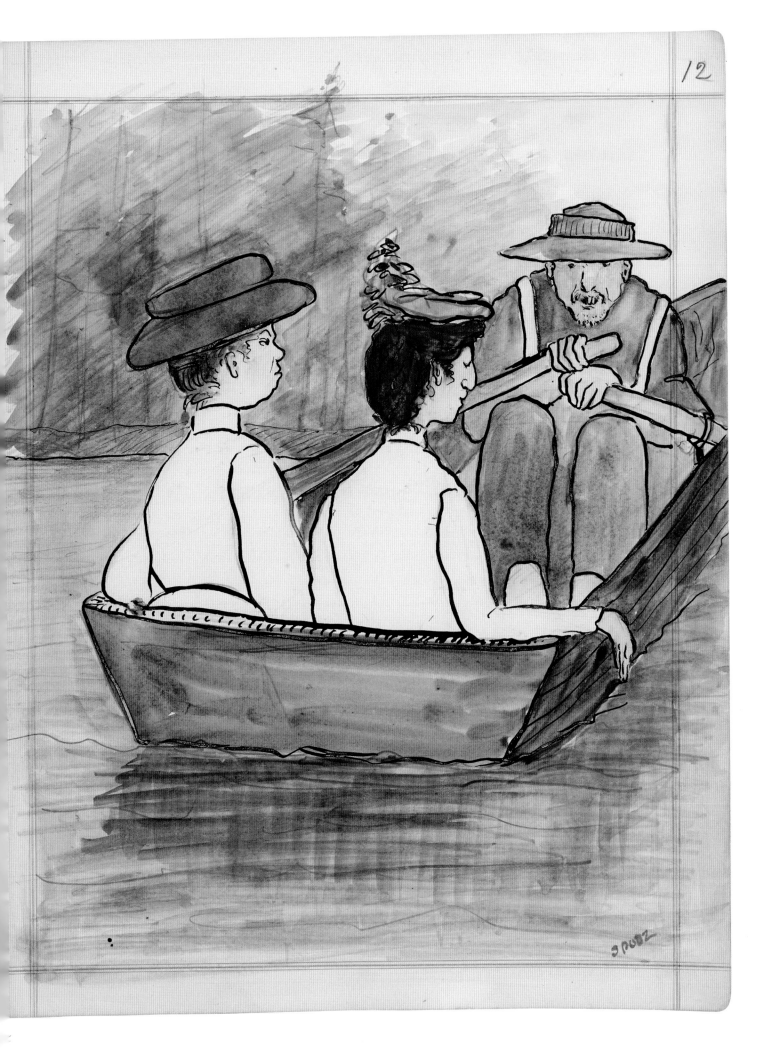

HAVING BEEN UNFORTUNATE IN OUR FIRST TRIP
TO THE SUMMIT, WE TRIED IT AGAIN, UNDER MORE
FAVOURABLE ASPECTS. INDEED THE DAY WOULD
HAVE BEEN ONE OF UNALOYED PLEASURE, HAD
NOT A MAMMOTH COLONEL ELECTED TO SHARE
MY SEAT IN THE TRAIN, WHICH PAINFULLY COMPRESSED
ME.

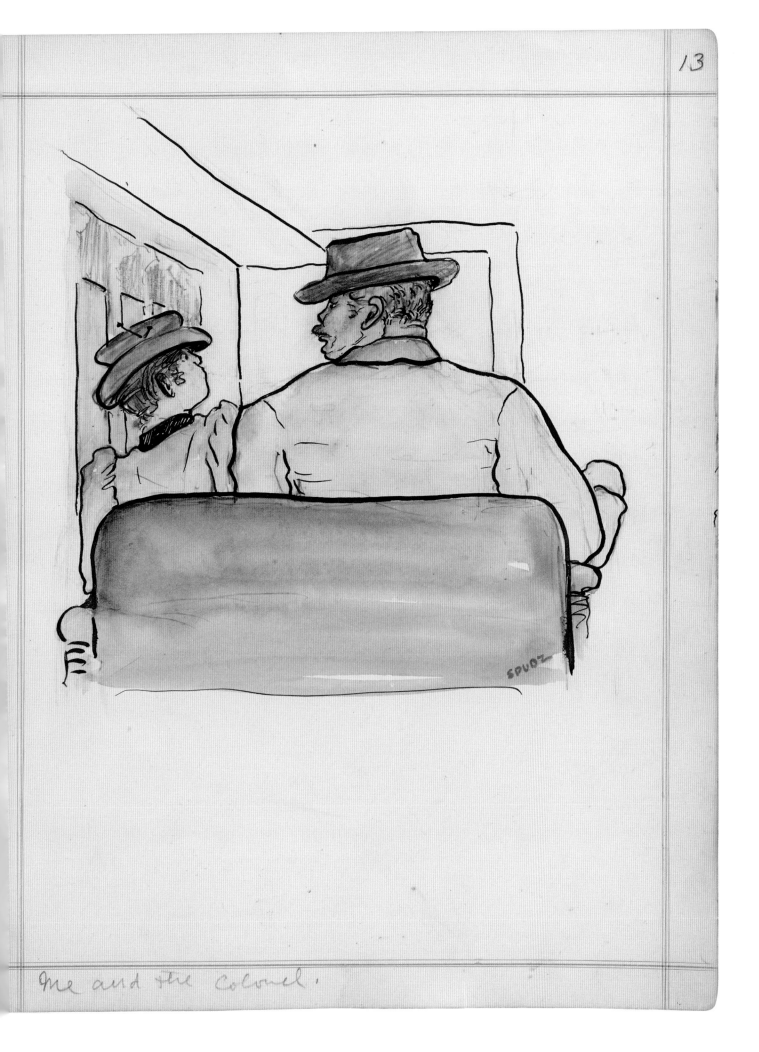

Me and the Colonel.

AND IT WAS WITH PLEASURE THAT WE STEPPED
FROM THE TRAIN AND PERCEIVED THE
"PULLEN 'OUSE BUSS" AWAITING US,

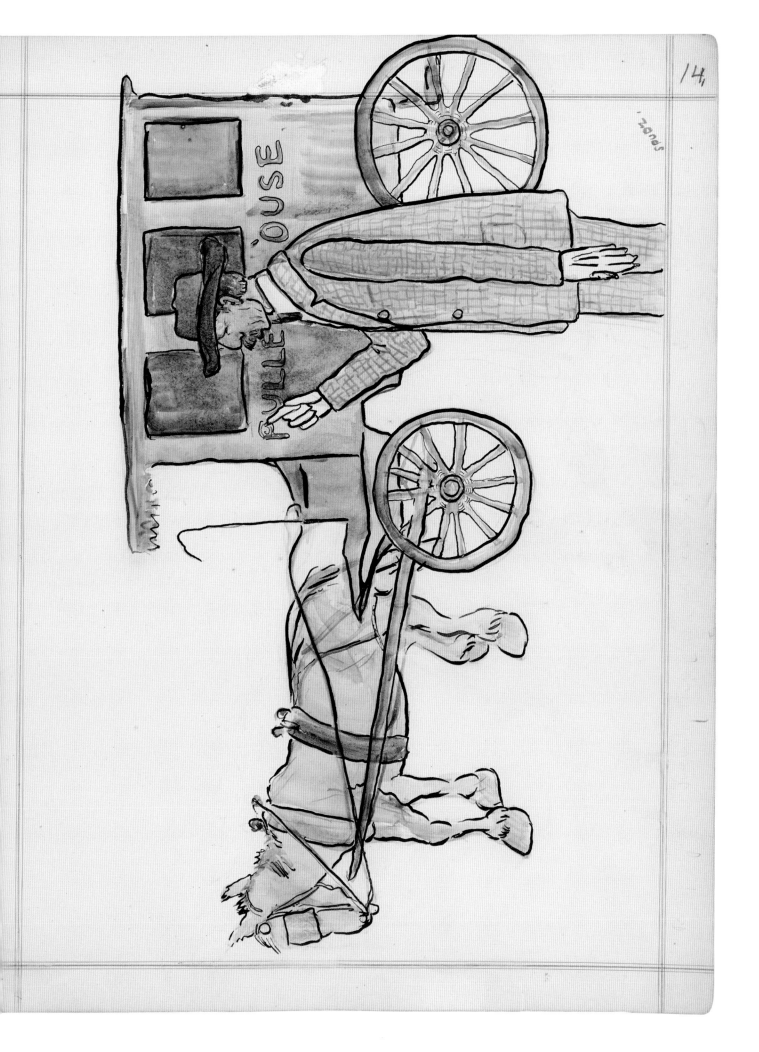

THE TRIP UP THE WHITE PASS BEING FAMED FOR ITS
BEAUTY, THE TRAIN STOPS AT STATED INTERVALS,
AND ALL POSSESSORS OF CAMERAS AND KODAKS
ALIGHT; AND AT A SIGNAL FROM THE RED HAIRED
CONDUCTOR, THEY PRESS BUTTONS, AND SQUEEZE
BULBS, IMMORTALIZING WHATEVER IS BEFORE THEIR
KODAK'S EYE (OFTEN THEMSELVES).

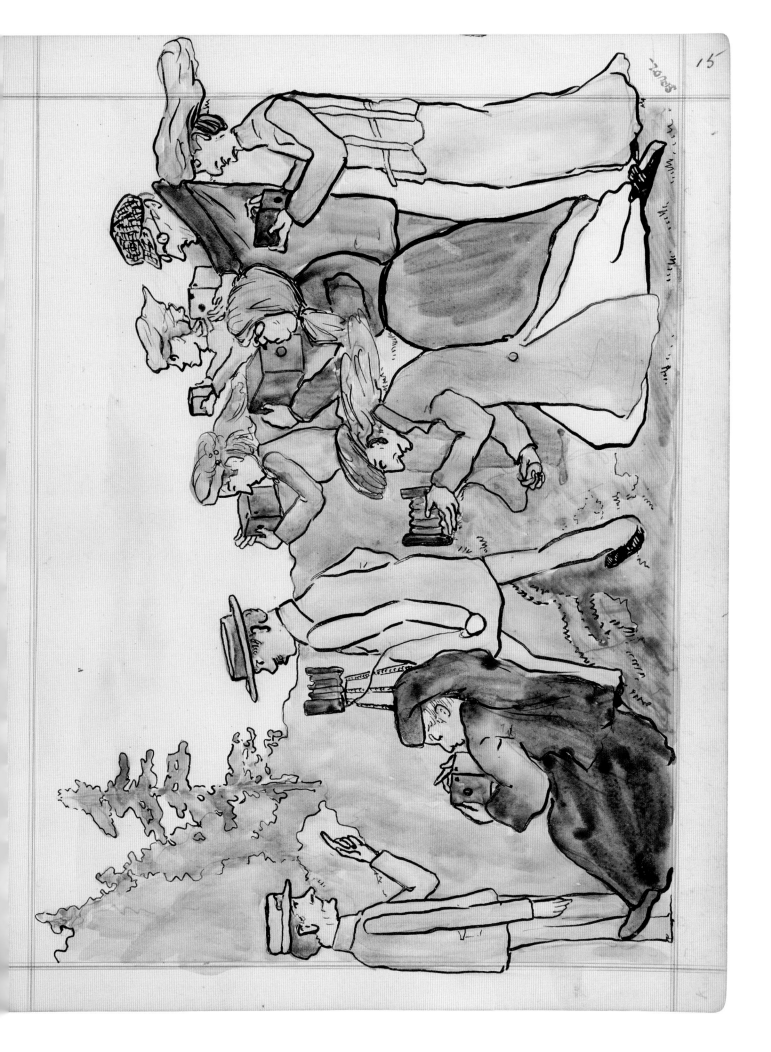

IF BY CHANCE I HAPPENED TO GO TO SISTER'S ROOM ABOUT AN HOUR AFTER SHE HAD RETIRED FOR THE NIGHT, I FOUND HER ABSORBED IN HER DIARY, A CHRONICAL OF STATISTICS COLLECTED DURING THE DAY TO EDIFY THE LOVED ONES AT HOME.

EXTRACT FROM SISTERS DIARY

SUMMARY OF SKAGWAY.....—

Situation = on river bed

Climate = unceasing rain and moaning wind

Products. = wild berries. crazy men. & cream

Inhabitants = Mostly Absent.

WE TRAVELLED FROM SKAGWAY TO SITKA ON THE
JEFFERSON. ARRIAVING IN SITKA AT 6. A.M. WE
WERE ESCORTED UP THE MAIN ST BY THE TOWN
GOAT; AMIABLE ANIMAL AS LONG AS WE EACH
RUBBED ONE·EAR, BUT TREATCHEROUS THE MOMENT
WE TURNED OUR BACKS IN QUEST OF·A HOTEL,
POOR SISTER!—BUT SHE MAINTAINED HER IMPENATRIBLE
CALM. THO' TOUCHED WITH MELANCHOLY.

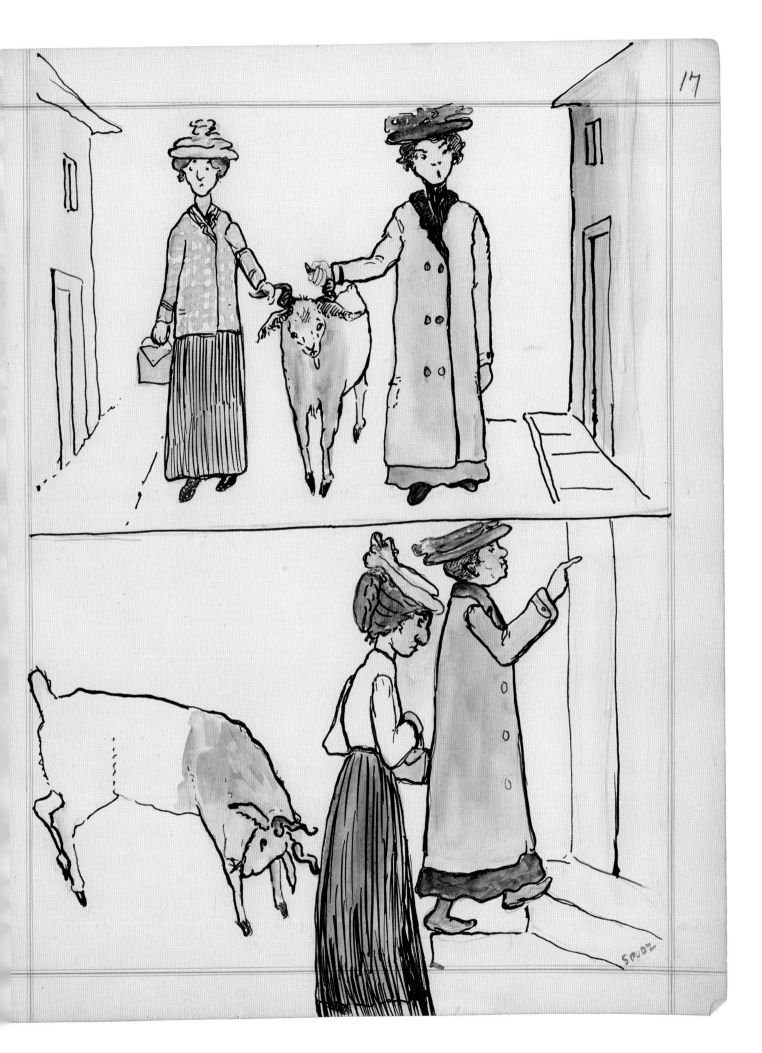

RECOVERING OUR EQUINAMITY, AND PROCEEDING ON OUR WAY: WITH OUR HANDS DISCREETLY BEHIND US, WE ENCOUNTER OUR OLD SKAGWAYAN FREIND, 'LA TOTEM' BOWING PROFOUNDLY BEFORE US.

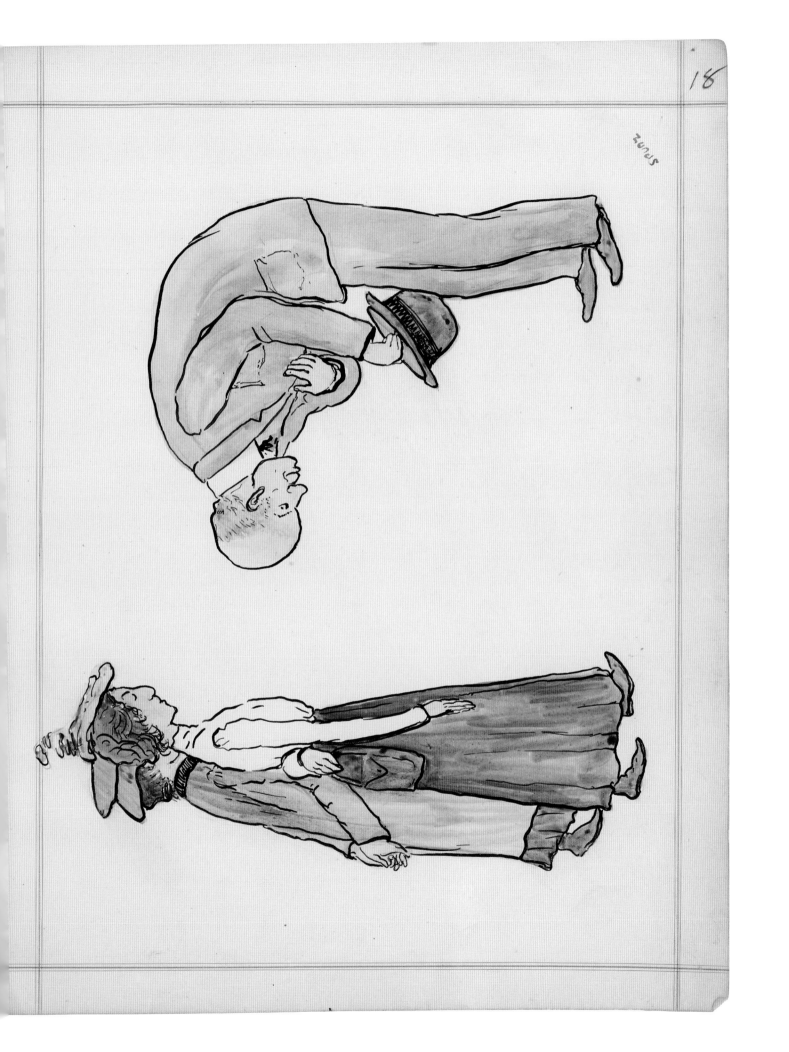

WE ARE IMMEDIATLY ADOPTED, AND STRAIGHTWAY TAKEN FOR OUR INITAITION TRIP TO THE TOTEM POLES, AND THEREAFTER BOURN THITHER TWICE DAILY, FOR THE REST OF OUR SOJOURN IN SITKA, BE THE CLIAMATIC CONDITIONS FAVOURABLE OR UNFAVOURABLE.

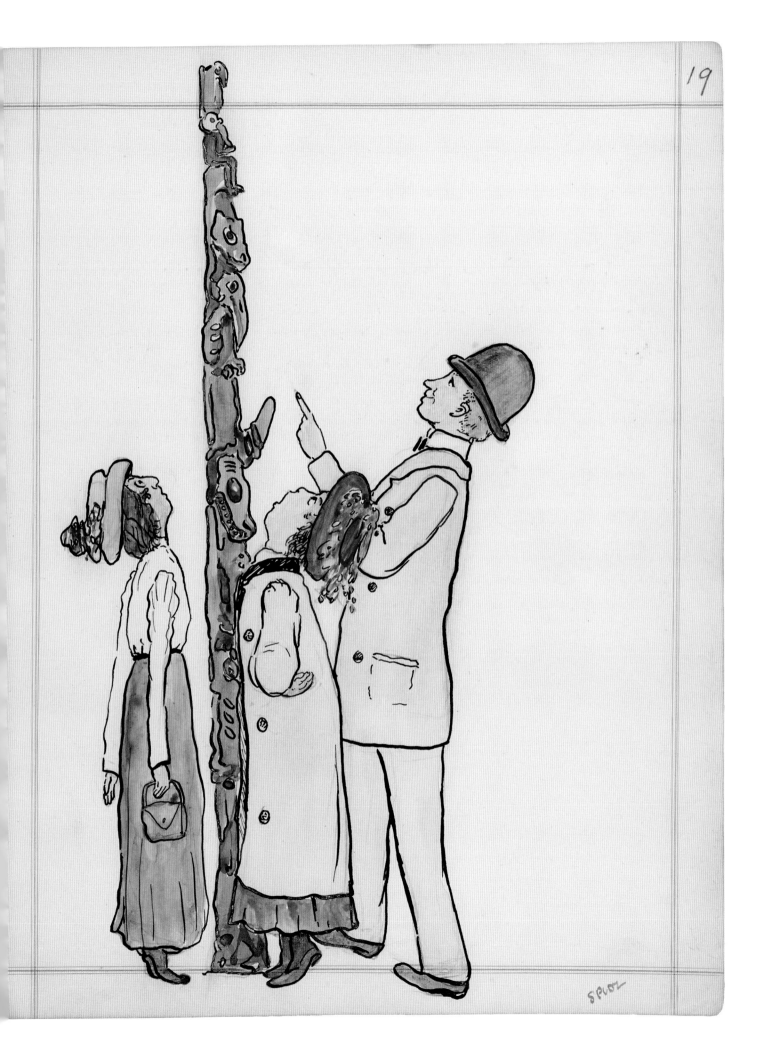

THE WEATHER AND OUR GENERAL HEALTH BEING
EXCELLENT, LA TOTEM SUGGESTS A CLIMB UP
"MT VESTOUIAS" THIS MOUNTAIN EXCESSIVELY STEEP
AND RUGGED AND REACHING ALMOST TO THE HEAVENS
LIES IN THE REAR OF SITKA, THER BIENG BUT
ONE OBSCURE TRAIL, TO LOOSE WHICH IS CERTAIN
DEATH. WE AROSE AT DAWN AND WRESTLING
WITH AN AGONY OF SLEEP: BUT WELL PROVIDED
WITH LUNCHEON, WE STARTED FOR THE LAUNCH
THAT WAS TO BEAR US TO THE FOOT OF 'VESTOUIAS'

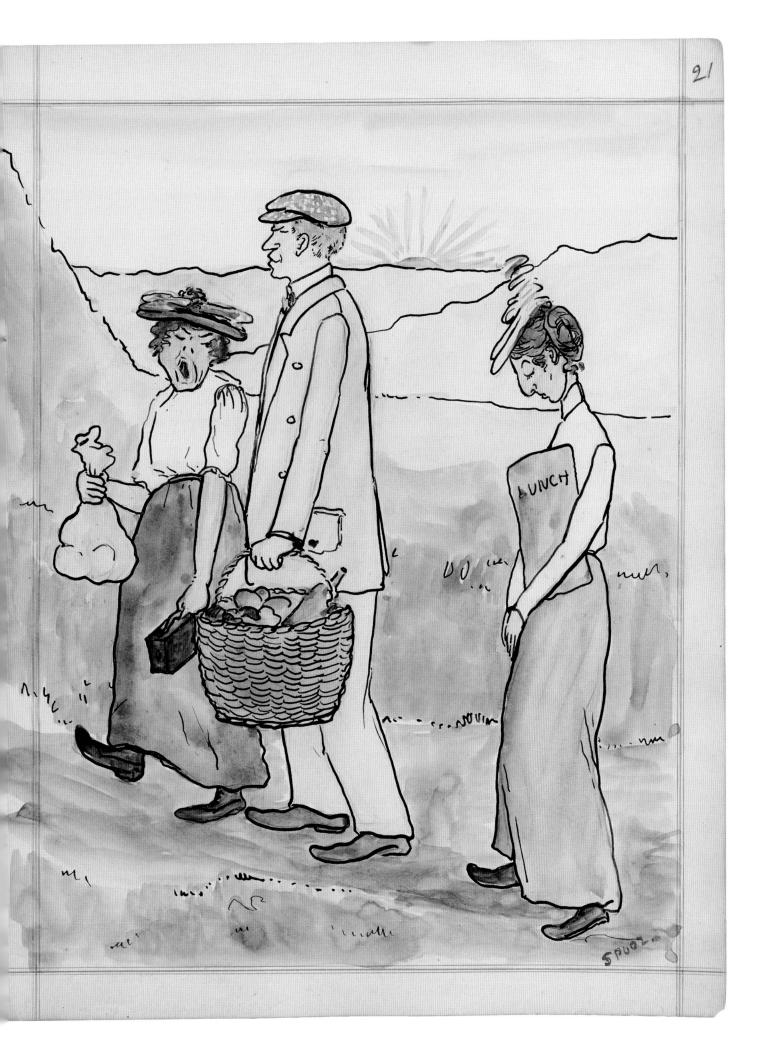

THIS PART OF OUR JOURNEY ACCOMPLISHED IN
SAFETY, WE PLUNGE IN TO THE DEEP FORREST
SURROUNDING THE MOUNTAIN AND PREPARE TO FOLLOW
THE TRAIL AT ALL COSTS, LA TOTEM WITH THE
BUOYANCY OF YOUTH (HE IS ONLY 30 THO' BALD) SPRINGS
UP THE SIDES OF THE CLIFFS, GALLANTLY BEARING
THE LUNCHEON, WHILE SISTER AND I FOLLOW AT OUR
SPEED LIMIT, WRIGGLING UNDER LOGS, AND OVER
LOGS, SQUEEZING BETWEEN GREAT TREES, HANGING
ON BY ROOTS AND FORDING WATER-FALLS.

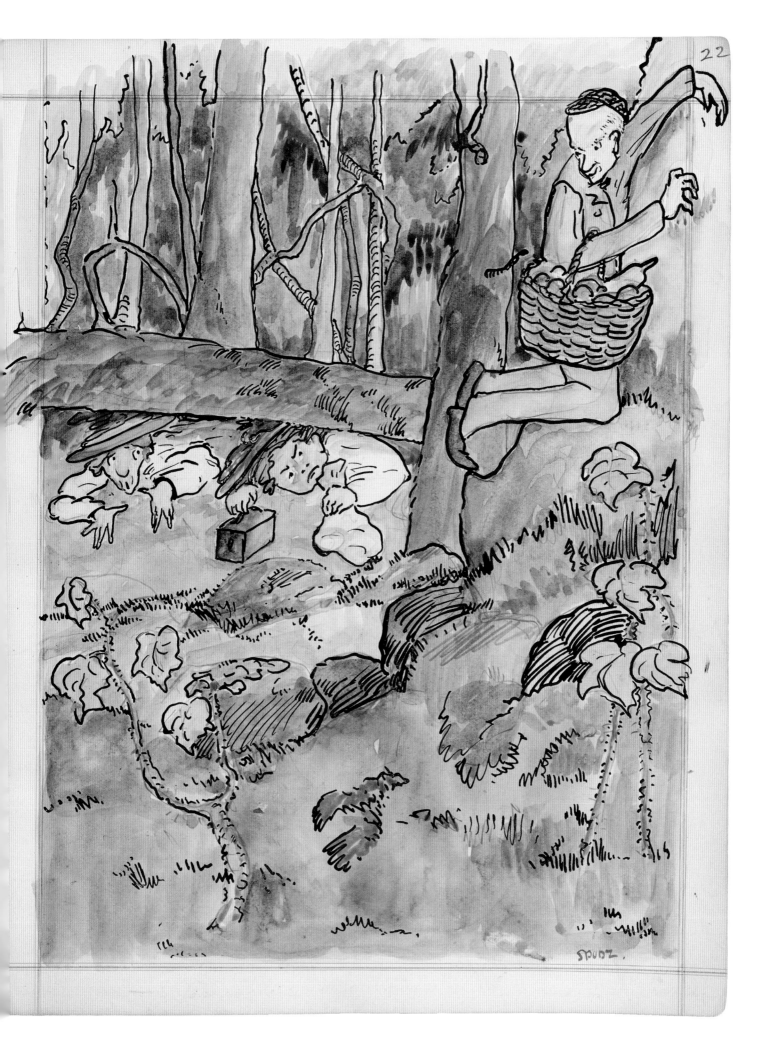

SPUDZ.

THERE ARE HAZARDOUS PRECIPICES TO BE SCALED
WHICH RENDER POOR SISTER FAINT AND GIDDY,
BUT THE STRONG HAND OF 'LA TOTEM' IS EVER READY
TO ASSIST HER. WHILE I CRAWL UP LIKE A BUGG.

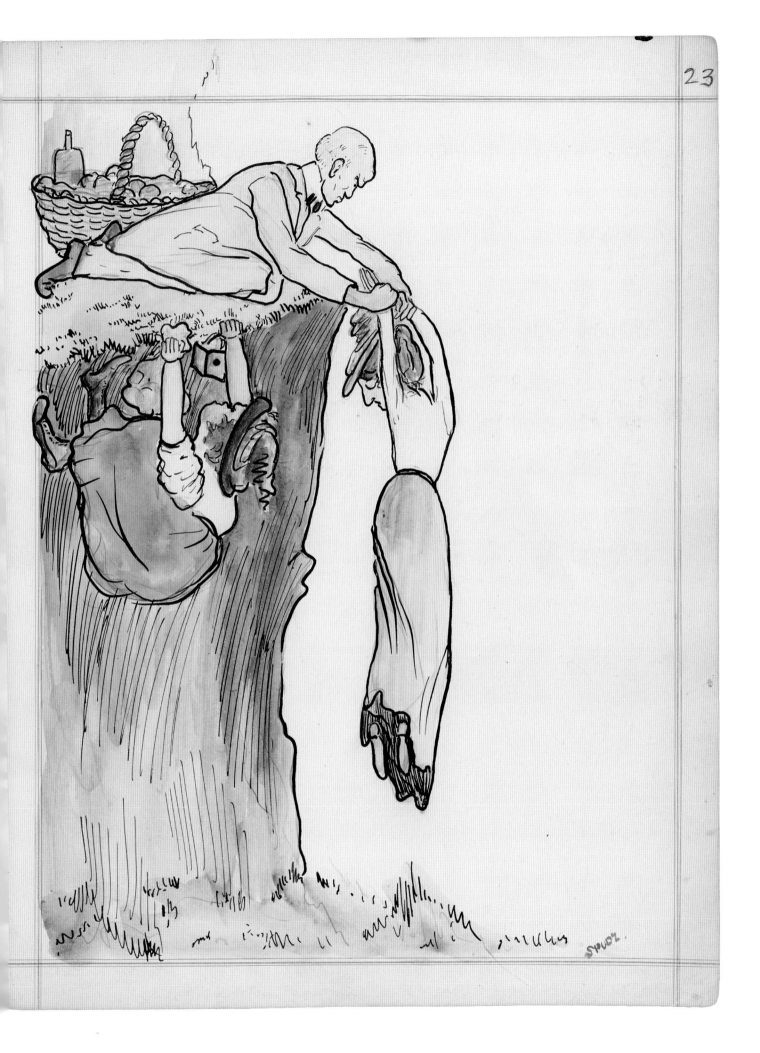

AS THE SUN RISES AND THE TRAIL BECOMES STEEPER AND MORE OBSCURE, WE DISCARD THOSE OF OUR GARMENTS WHICH CAN ADVANTAGEOUSLY BE DESPESSED WITH, PETICOTE FRILLS, SHOE HEELS, GOLLOSHES, EVEN MY CHARMING PLAID HAT, WE THOGHT TO COLLECT OUR APPAREL ON OUR DOWNWARD WAY,—ALAS. PROVIDENCE INTERVENED! AND A SPORTIVE WILD BEAST INTOXICATED WITH SUCKING ONE OF OUR LUCIOUS ORANGES DONNED THE OUTFIT. .

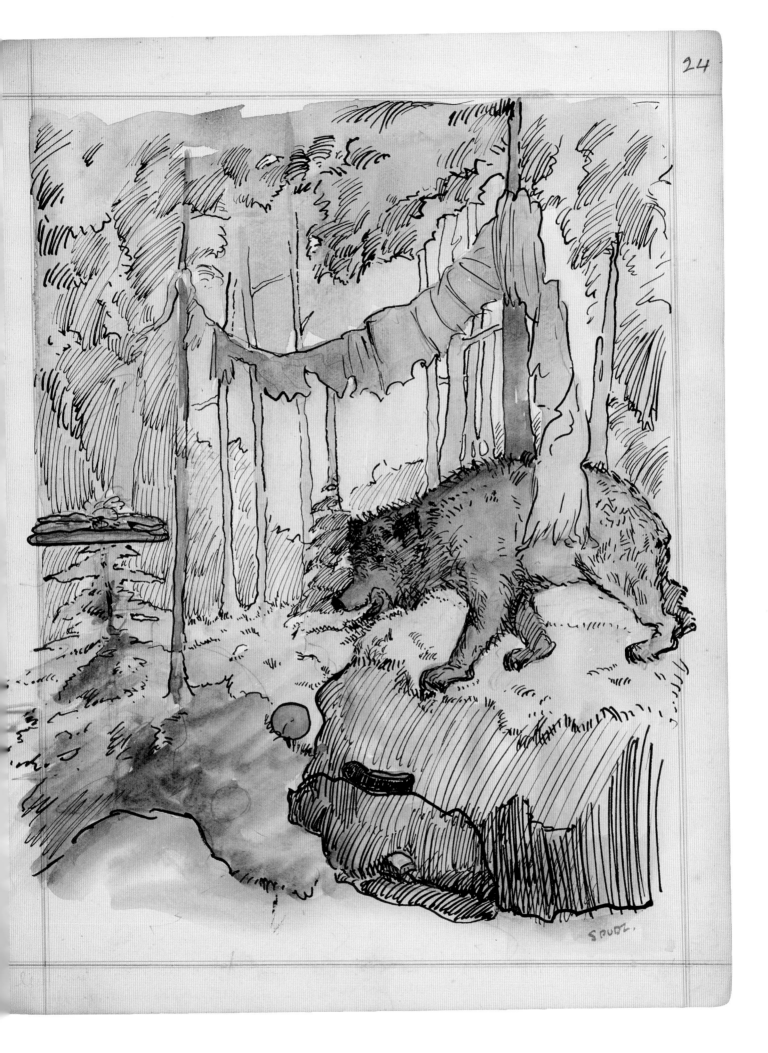

TO THE UNDOING OF A BRAVE AND GALLANT
SPORTSMAN.

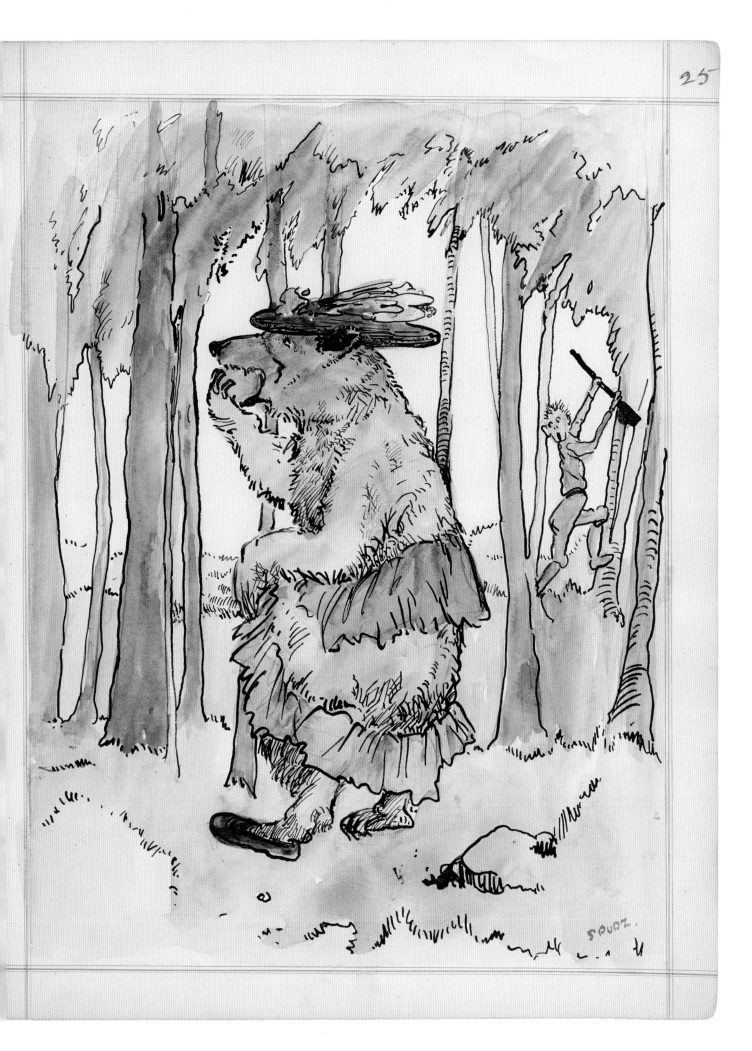

REACHING THE SUMMIT AT LENGTH, MY SISTER IN A STATE OF COMPLETE EXHAUSTION, CAST HERSELF ACROSS THE LIMB OF A TREE, WHILE I LAY PRONE UPON THE GROUND, AND 'LA TOTEM' THE INEXHAUSTIBLE SOUGHT YET ANOTHER PEAK.

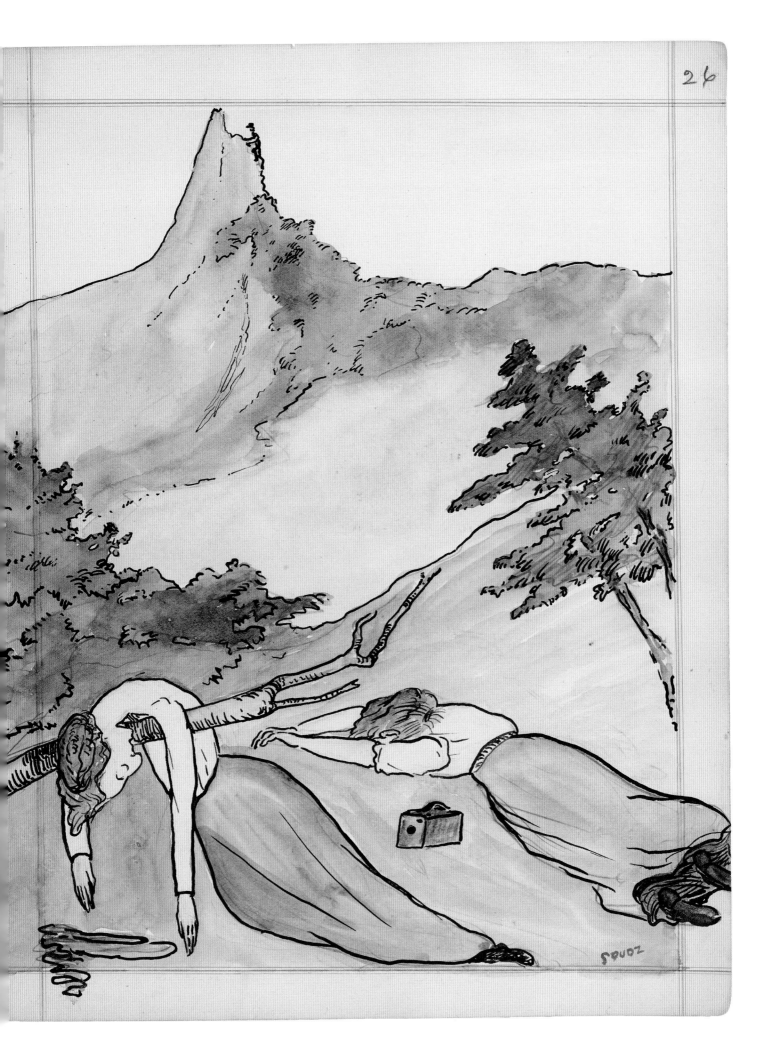

A FEW HOURS OF REST, LUNCHEON, AND THE
EXPANSION OF OUR SOULS UPON THE MAGNIFICENT
AND FAR REACHING VEIW, RESTORE US SUFFICIENTLY
TO ATTEMPT THE RETURN JOURNEY, WHICH PROVES
TO BE AS HAZARDOUS AS THE ASCENT: AND IS PER-
FORMED IN MANY STRANGE POSTURES.

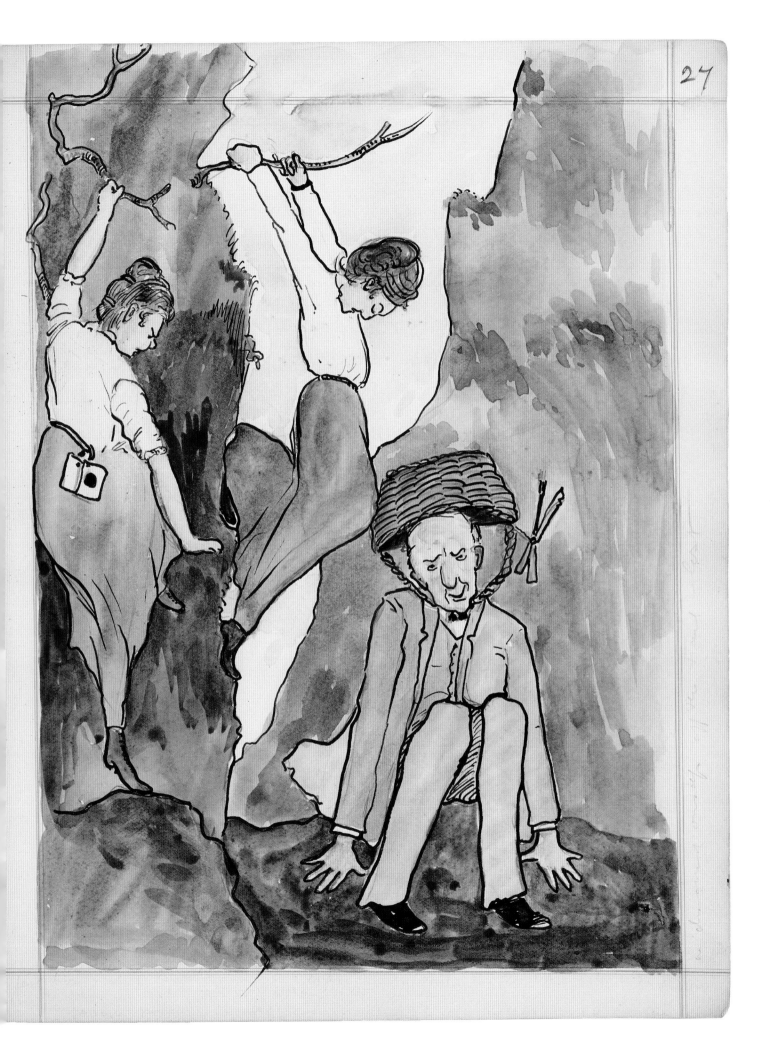

All WENT WELL UNTILL TO OUR CONSTERNATION WE
DISCOVERED OURSELVES TO BE OFF THE TRAIL,
SISTER AND I SAT UPON A LOG AND FACED DEATH,
WHILE 'LA TOTEM' ON HIS HANDS AND KNEES,
SOUGHT EARNESTLY. FOR THE TRAIL.

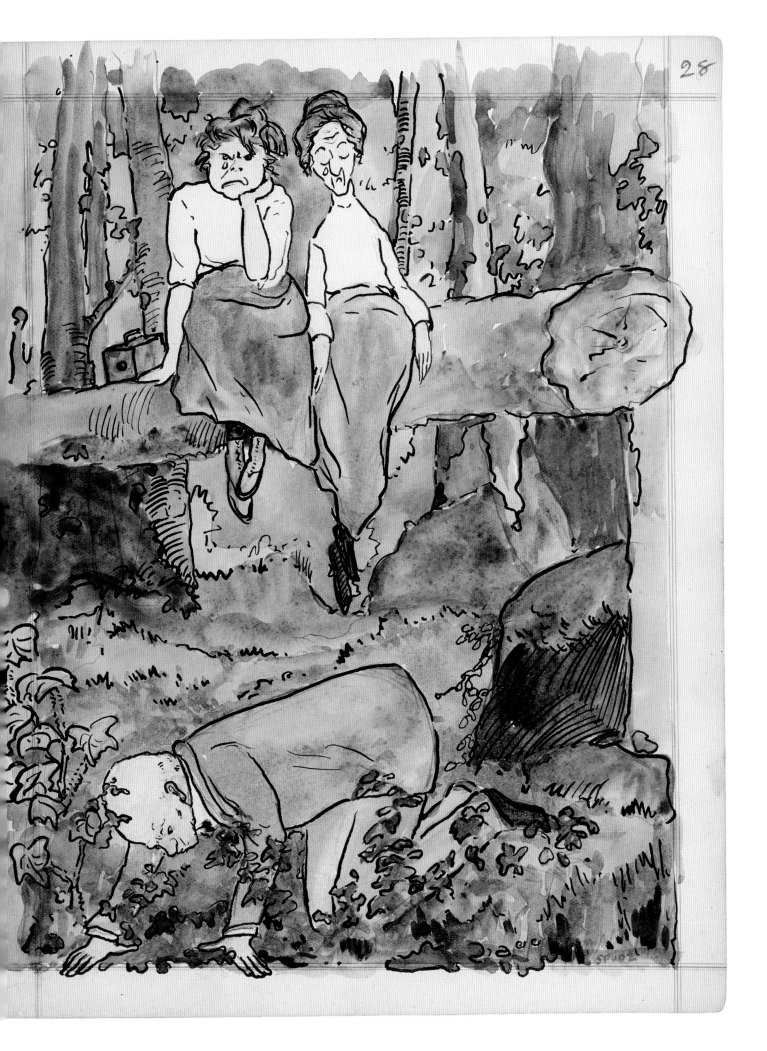

FAILING TO DISCOVER ANY TRACES, OF THE LOST PATH
AND FEELING THE RESPONSIBILITY OF HAVING TWO
'WEAK WOMEN' THRUST UPON HIM, 'LA TOTEM' BECAME
DISTROUGHT, AND RUSHED HEADLONG THROUGH THE
FOREST; SHOUTING, "MEIN GOTT WE ARE LOOSED"
SISTER AND I FOLLOWED AS BEST WE COULD, WITH
FAILING STRENGTH AND GASPING BREATH.

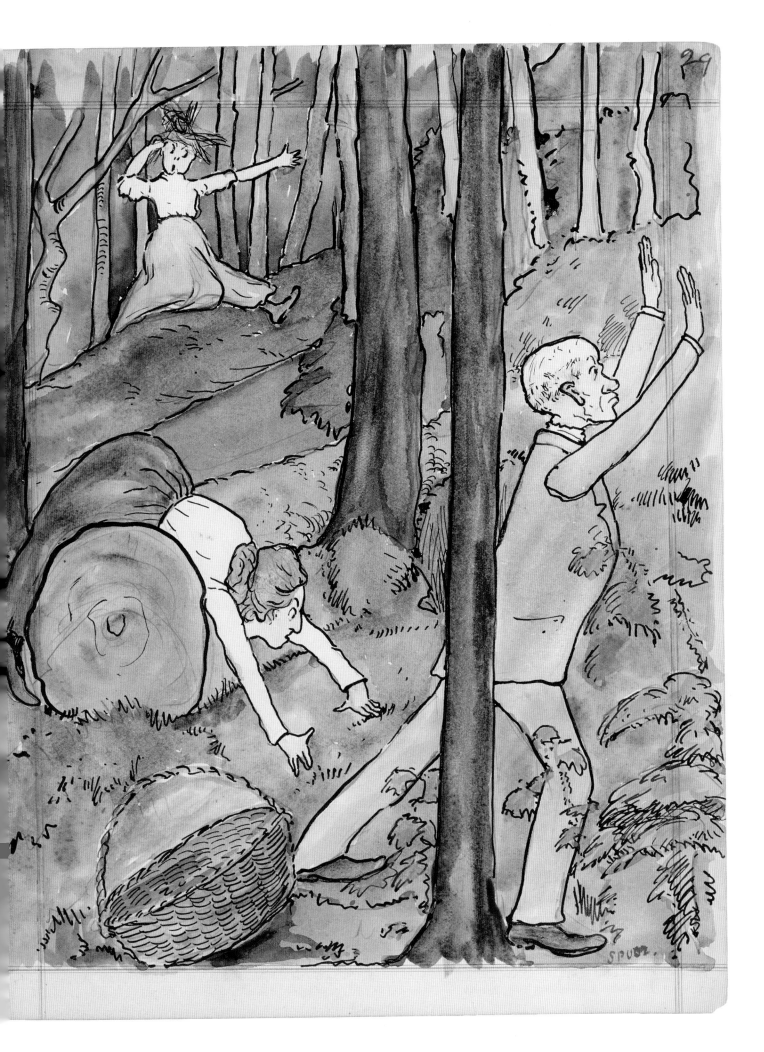

FOR HOURS WE WANDERED THUS, TILL TWILIGHT FELL AND DESPAIR O'ERSHADDOWED US, SISTER AND I SANK PRONE, BUT 'LA TOTEM' REFUSED ALL REST, SAVE THAT TAKEN IN A STANDING POSTURE, THUS DID WE WAIT THE END WITHOUT A GROAN, WHEN LO! AMID THE FOREST NOISES AND GROWLINGS OF WILD BEASTS. A FAR OFF PALPITAING PUFF; AND THEN, AH JOY! THE INTOZICATING SWEET PERFUME OF GASOLINE! HOPE STIRRED OUR BREASTS; AND TEARS BEDIMMED OUR EYES. SO GUIDED BY THAT PALPITATING PUFF, AND ODOUR SWEET, WE REACHED THE SHORE. WHERE ⸺

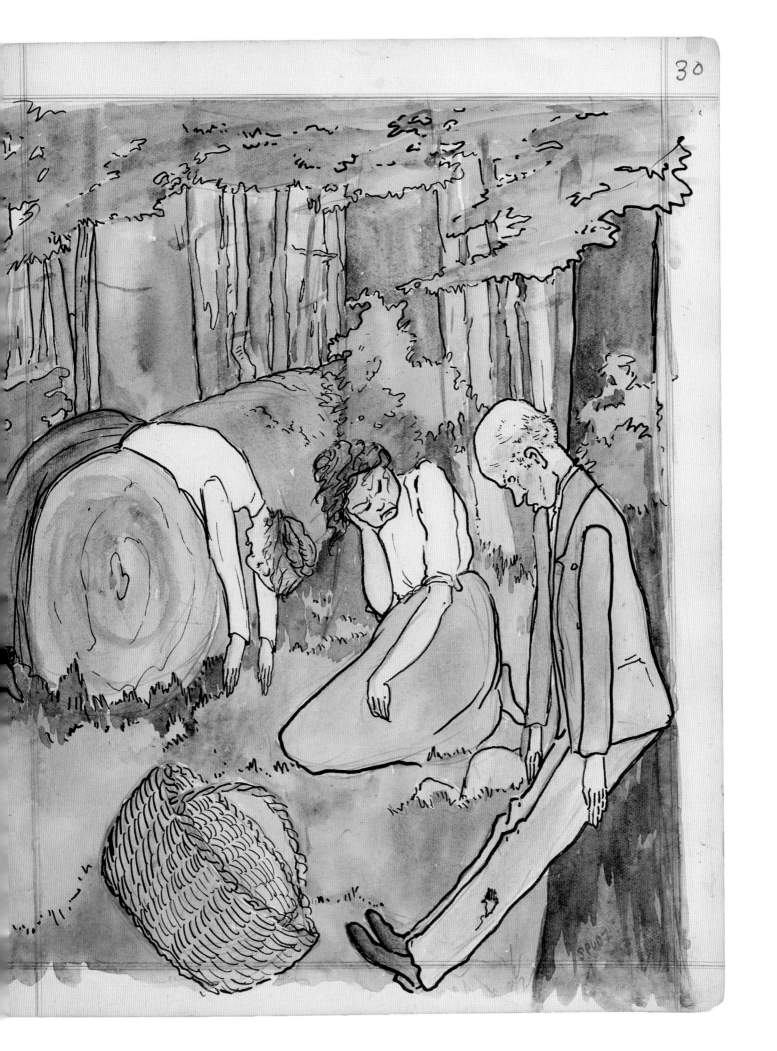

FALLING ON OUR KNEES WE GAVE DEVOUT THANKSGIVING.

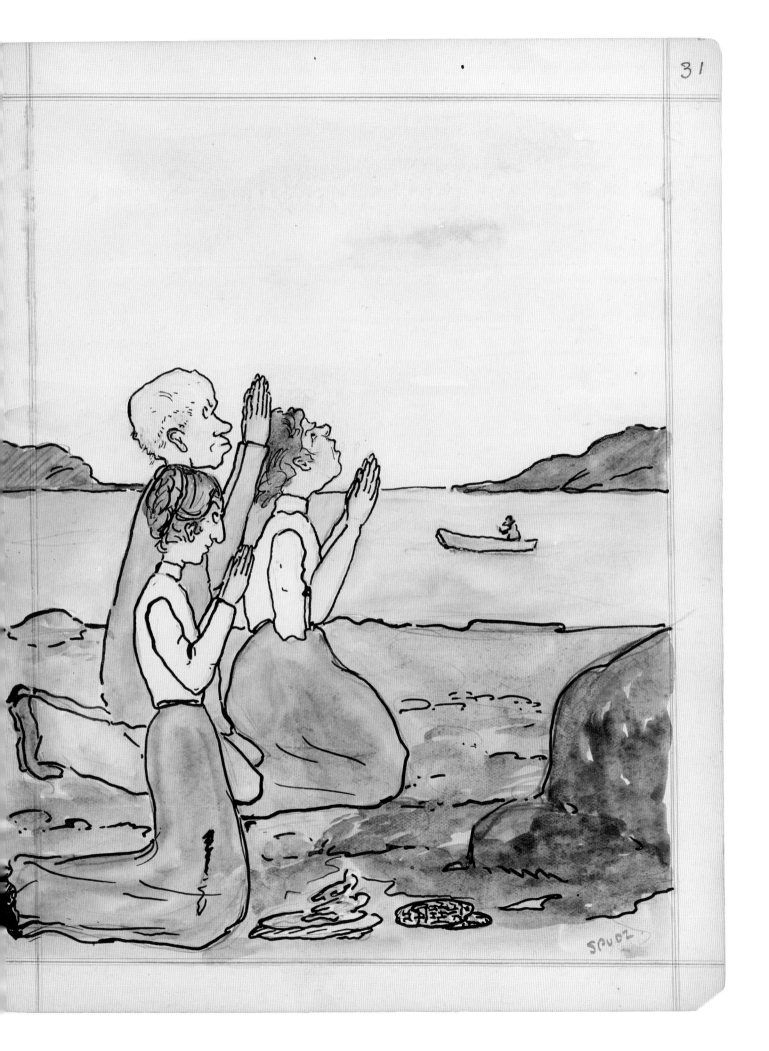

AND THUS WITH ACHING LIMBS, BUT THANKFUL
HEARTS, WE TOILED PAINFULLY UP THE VILLAGE
ST., WHILE THE GOAT AND ROOKS LOOKED DOWN
UPON US IN PERPLEXED SYMPATHY.

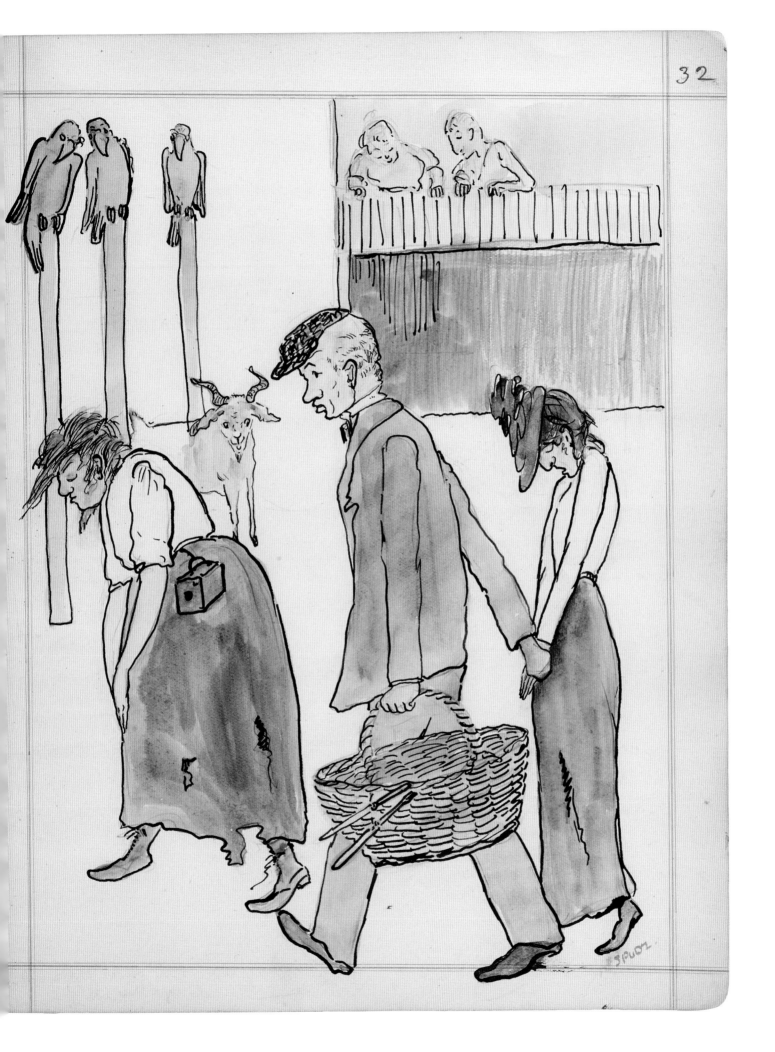

BEFORE WE HAD FULLY REGAINED OUR USUAL HEALTH AND SPIRITS. A DIRE CALAMITY BEFELL US, LAYING MY PURSE WITH ALL MY WORLDLY WEALTH THEREIN, UPON A WINDOW LEDGE, THAT SHOULD HAVE BEEN THERE BUT WAS NOT; IT DECENDED BETWEEN THE TWO WALLS OF THE HOUSE: OUR PUNURIOUS CONDITION OVERTAKING US WHILE YET UNNERVED FROM OUR MOUNTAIN HARDSHIPS, CAUSED US EXTREME MENTAL DEPRESSION : ___ JUST AT THE MOMENT THAT WE HAD DECIDED UPON THE HONOURABLE, BUT HARRASSING NECESSITY, OF SETTLING OUR HOTEL BILL WITH OUR WARDROBES, AND WORKING OUR WAY HOME DISGUISED AS DECK-HANDS, THE CALAMITY WAS AVERTED BY A TRAVELLING CARPENTER SKILLED IN THE UNBUILDING OF HOUSES, WHO RECOVERED OUR POSESSION AND RESTORED US TO TRANQUILITY.

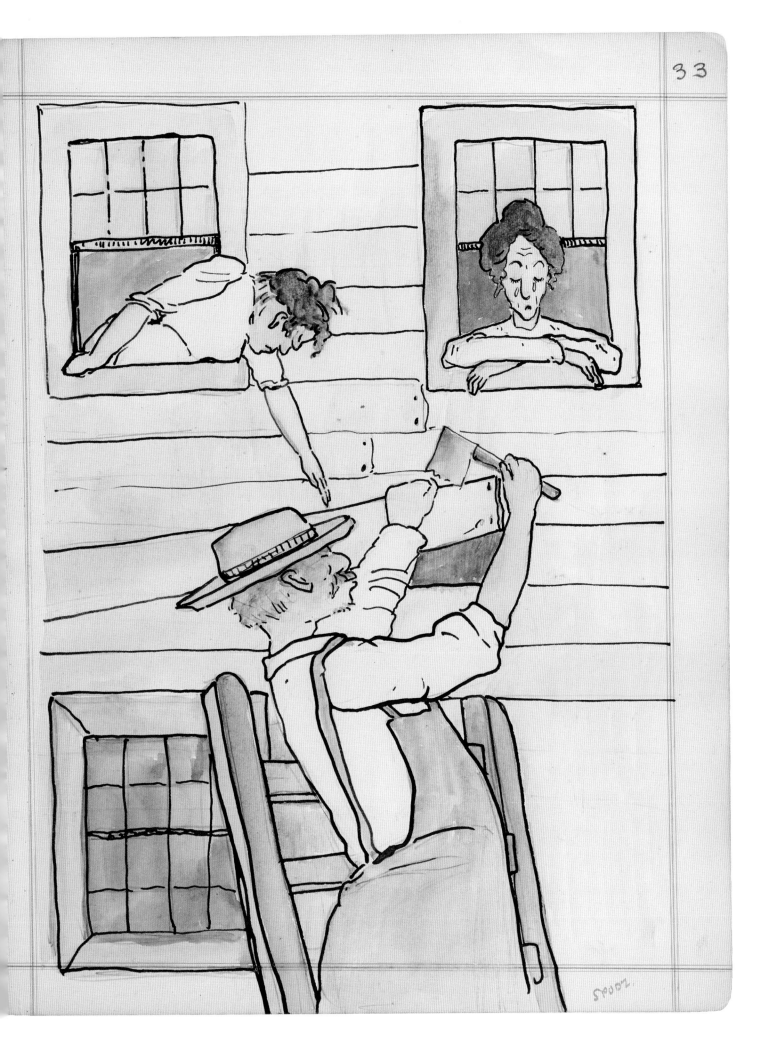

LADY JUNO (ALIAS ST JUNO) ARTIST AND MISSIONARY

FOUNDER OF THE CHRISTIAN FAITH IN ALASKA.

PAINTER OF EAGLES.

PURLOINER OF TOAST AND TEASPOONS.

PILLAR OF THE CHURCH.

THERE WERE MANY INTERESTING AND NOTABLE
PERSONAGES AT OUR HOTEL, PROFESSORS, EXPLORERS,
AND ARTISTS, INDEED IT WAS IN THIS VERY HOTEL
THAT LADY FRANKLIN WAITED IN VAIN FOR THE
RETURN OF HER HUSBAND FROM THE POLE; WHICH
IS STILL A SOURCE OF INCOME TO THE LANDLORD,
WHO CHARGES ADMISSION TO TOURISTS, TO BEHOLD
THE PATH WORN BY HER WEARY FEET UPON THE
CARPET IN HER MIDNIGHT WATCHES, (LADY FRANKLIN
MUST HAVE WORN HEAVY BOOTS.) MORE INTERESTING
TO US WAS LADY JUNO THEN RESIDING THERE,
BY HER OWN ACCOUNT SHE WAS MIGHTY IN IM-
PORTANCE, BY OURS MIGHTY IN WEIGHT, LARGE
OF SOUL, LARGE OF FRAME, LARGE OF APPETITE,
INTENSELY RELIGEOUS, IMMENSELY CLEVER, SUCH
A PRODIDIGUOUS PATTERN OF PERFECTION, THAT
CONTACT WITH OUR WORLDLINESS, BROUGHT SALTY
TEARS, TO SATURATE HER SAINTLY PHYSOGOMY,

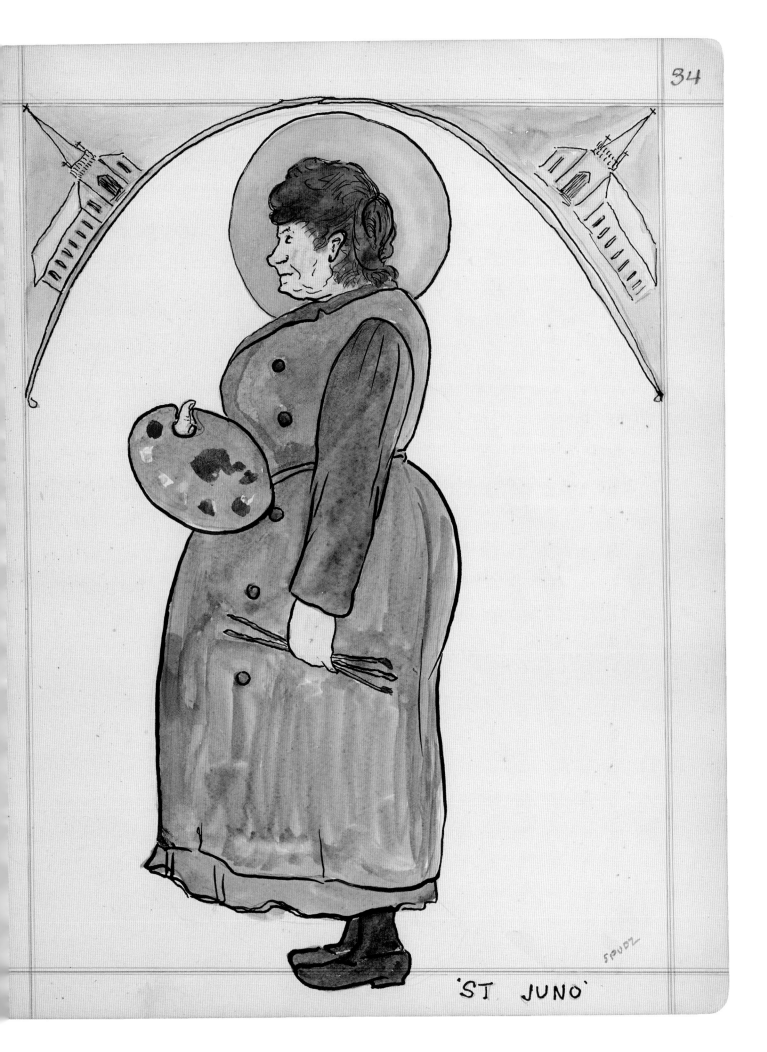

'ST JUNO'

AS THE DAY OF OUR DEPARTURE FROM SITKA
DREW NEAR, WE BETOOK OURSELVES TO THE
INDIAN VILLAGE, AND PROCURED A CURIO OR TWO
AS MOMENTOES OF OUR HAPPY TRIP, AND OFFERINGS
FOR OUR FREINDS; SISTER PURCHASED A BIRD OF MELANCHOLY
MEIN SO RESEMBLING HERSELF SHE HAD DIFFICULTY IN
RESTRAINING HER EMOTIONS, A SAD FACED SEAL-DISH,
AND OTHE TRIFLES: WHILE AN INDIAN TOM-TOM, A
BROW STRAP OF BEARS CLAWS, A DEER-HIDE, AND EAGLES
LEG. RENDERED ME JOYOUSLY HILLARIOUS; MY CHEIFES
DELIGHT BEING A HOLLOW BEARS TOOTH,
THROUGH WHICH I COULD WHISTLE TUNES, SECULAR
WHEN SURROUNDED BY ORDINARY MORTALS,
SACRED WHEN IN THE PRESENCE OF 'ST. JUNO'.

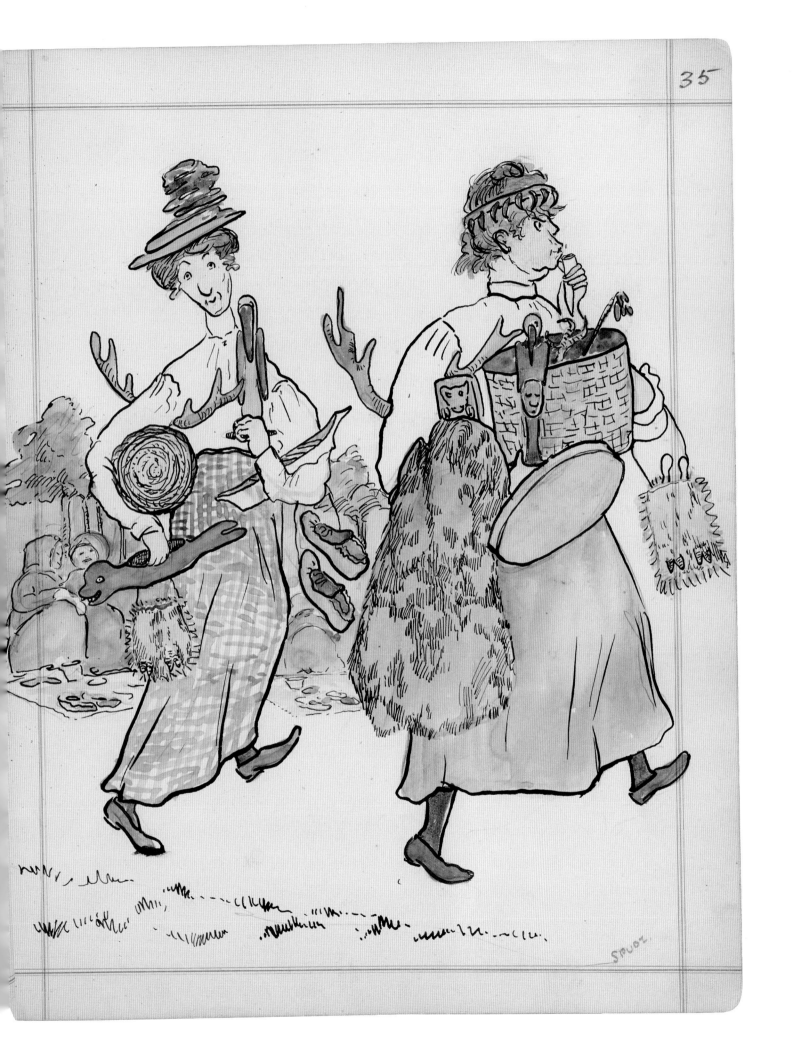

THE DAY OF OUR DEPARTURE FROM SITKA WAS
POURING WET, A CLIAMATIC CONDITION NOT
UNCOMMON IN THESE PARTS: OUR STOUT
UMBRELLAS, BEING PACKED, OUR CONDITION
WOULD HAVE BEEN PITIFUL, HAD NOT A MERCIFUL
YOUNG MAN, LENT US AN UMBRELLA, WHICH WE
GRATEFULLY ACCEPTED, THOUGH IT TOOK BOTH
HANDS, AND AN ATTITUDE OF EXHAUSTING
FATIGUE, TO INDUCE IT TO KEEP OPEN, BUT
THE YOUNG MAN SEEMED SO TO ENJOY SEEING
US CARRY IT THAT WE HAD NO HEART TO
REFUSE; THO' PERSONALLY I WOULD HAVE PREFERRED
A WETTING THAN THE DISLOCATED SHOULDER I
OBTAINED.

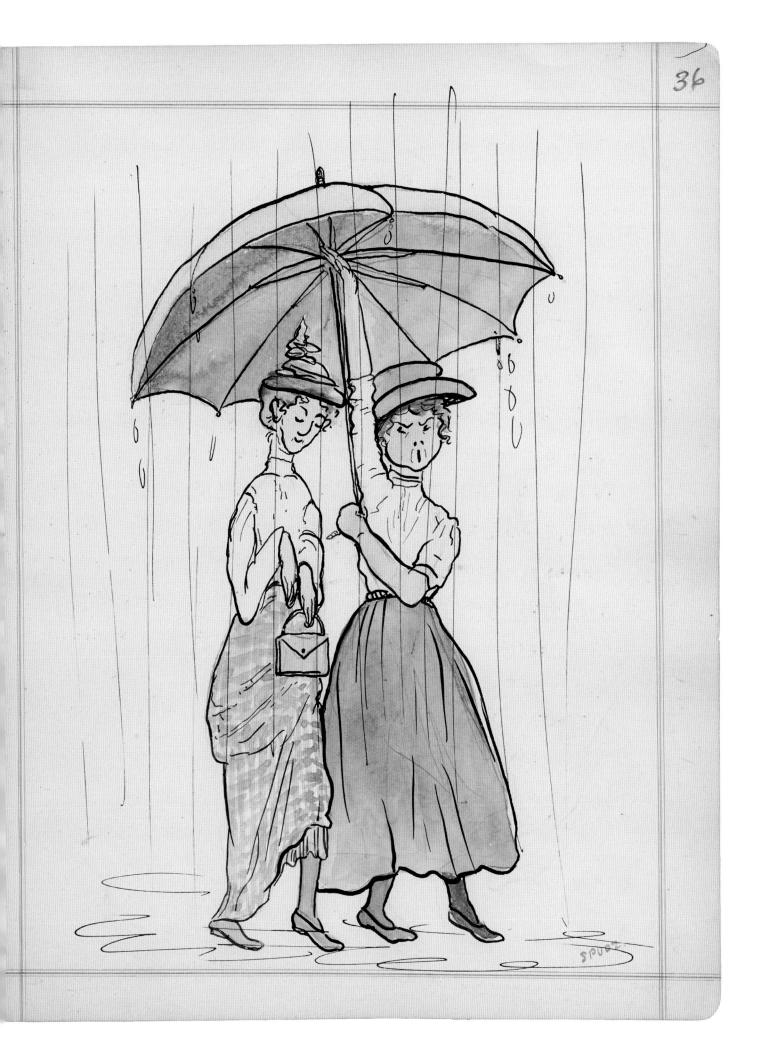

EXTRACT FROM
SISTERS DIARY —

Summary of SITKA.

Atmosphere = mountainous
and most romantic.

Products = Totem Poles. Rooks. + Russian Churches,

Population = Soldiers, Indians, Russians,
and goats.

AND NOW WE EMBARKED UPON THE S.S. DOLPHIN
HOMEWARD BOUND, ARRIAVING AT JUNEAU AT 5. A.M,
THIS IS ALL WE SAW OF IT'S BEAUTIES, SO
VIVIDLY DEPICTED TO US BY LADY JUNO.
THO' SISTER SAID THE 'SLIME UNDER THE
WHARF' "WAS A LOVELY GREEN" AND THE
'STARR-FISH TREMENDOUS'. WHILE THE ENTIRE
POPULATION PEERING OVER THE WHARF, LOOKED
AMIABLE AND FREE FROM VILLANY, DOUBTLESS
THE RESULT OF 'ST JUNO'S' MISSIONARY TEACHINGS.

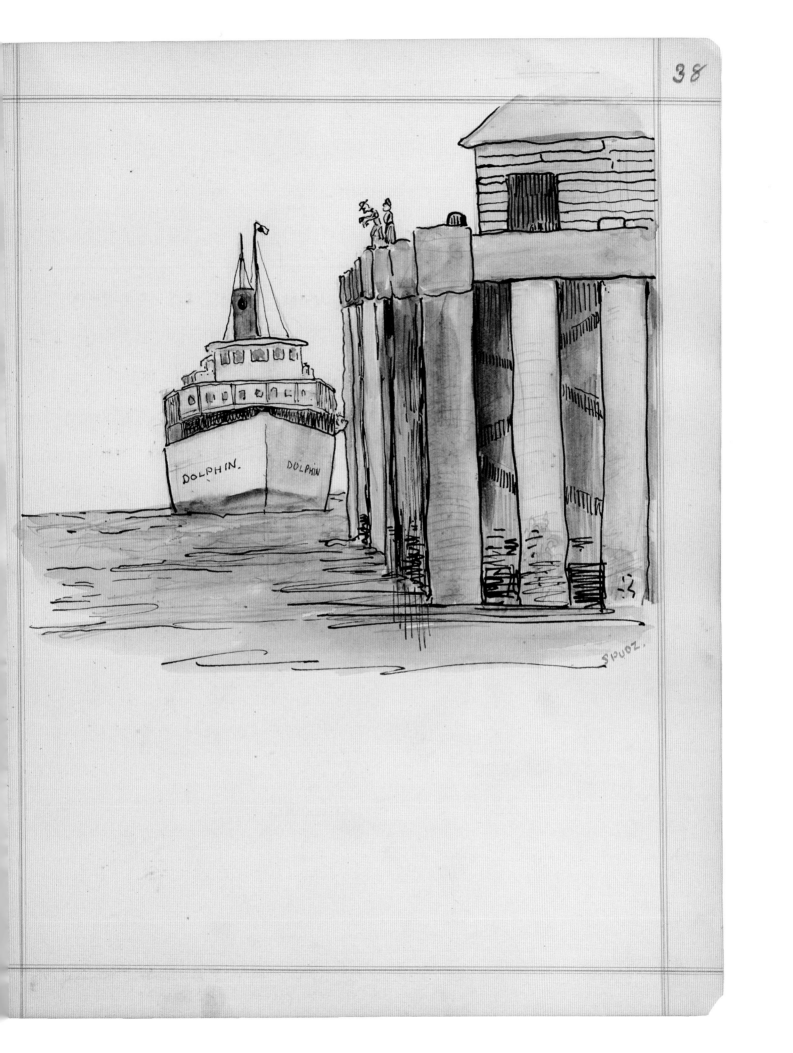

A FEW HOURS LATER WE ARRIAVED AT A CANNERY, AND JOINING THE THRONG OF RUBBER-NECK TOURISTS, WE ENDEAVOURED TO RISE SUPERIOR TO OUR NASEL ORGANS; AND INTELLIGENTLY TO ABSORD THE INTRICATE PROCESS OF SALMON CANNING.

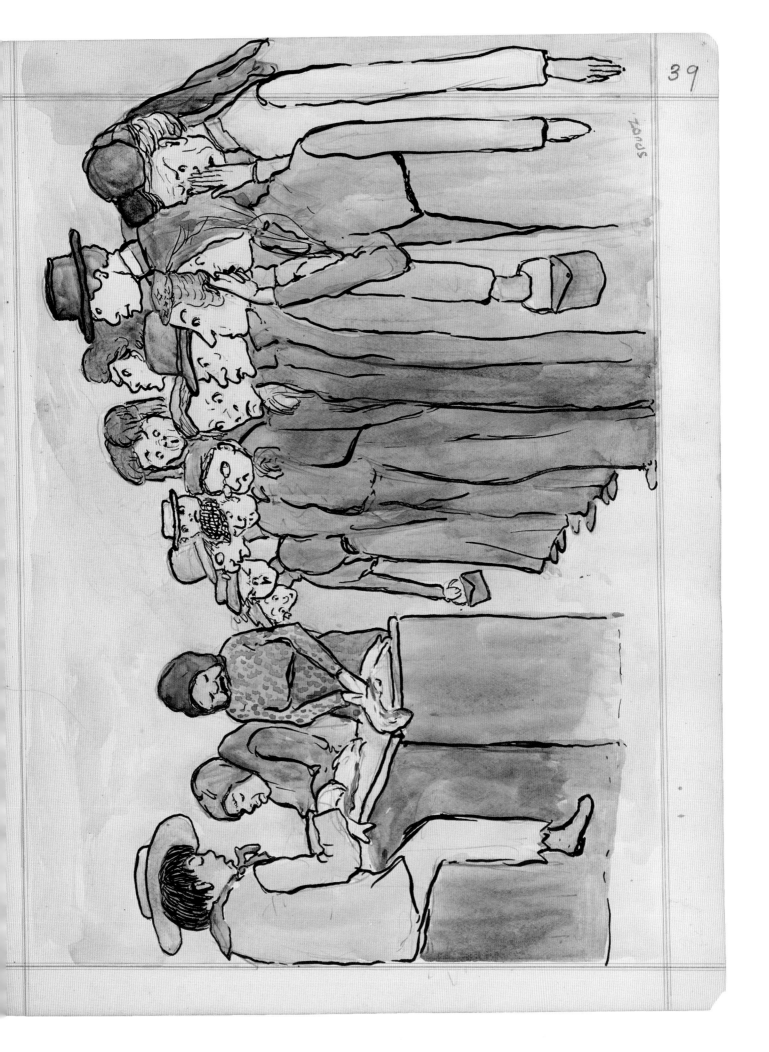

FORT WRANGLE WE REACHED AT MIDNIGHT, AND I
MUST CONFESS TO A SHRINKING FROM THE DUTY
OF "SEEING THE SIGHTS" DEVOLVING ON ALL AUTHORDOX
TOURISTS. SEEING HOWEVER WHAT WAS EXPECTED
OF US, WE CLASPED HANDS AND VALLIANTLY SET
FORTH ON A PEERING EXPEDITION INTO ITS
SPOOKY - DUSKY - LABRINTHS - WITH NERVE WRACKING
PERSISTENCY.

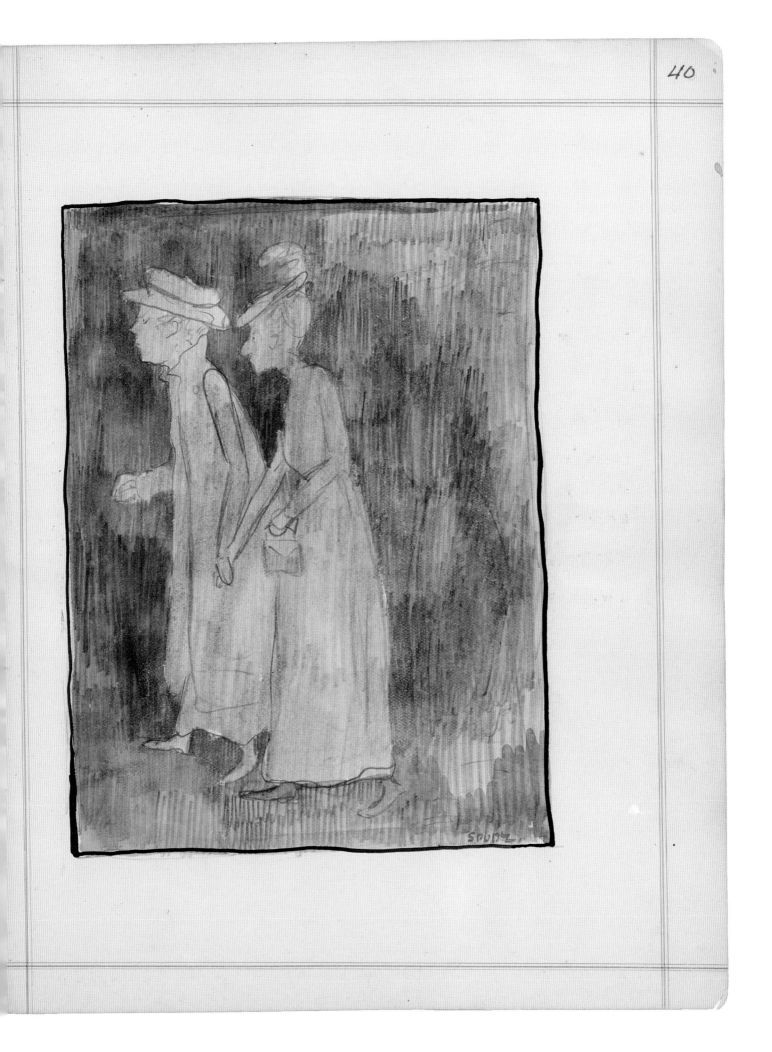

AT METLAKATLA WE INSPECTED THE CHURCH (AND
WE'RE EMBRASED ON OUR RETURN HOME, BY 'THE BISHOP'
FOR OUR 'RELIGEOUS FERVOUR') WE RENEWED AN OLD
ACQUAINTENCE WITH MR DUNCAN. AND BLUSHED
FOR OUR FELLOW PASSENGERS WHO LOOTED
THE POOR INDIAN'S RASPBERRY PATCH.

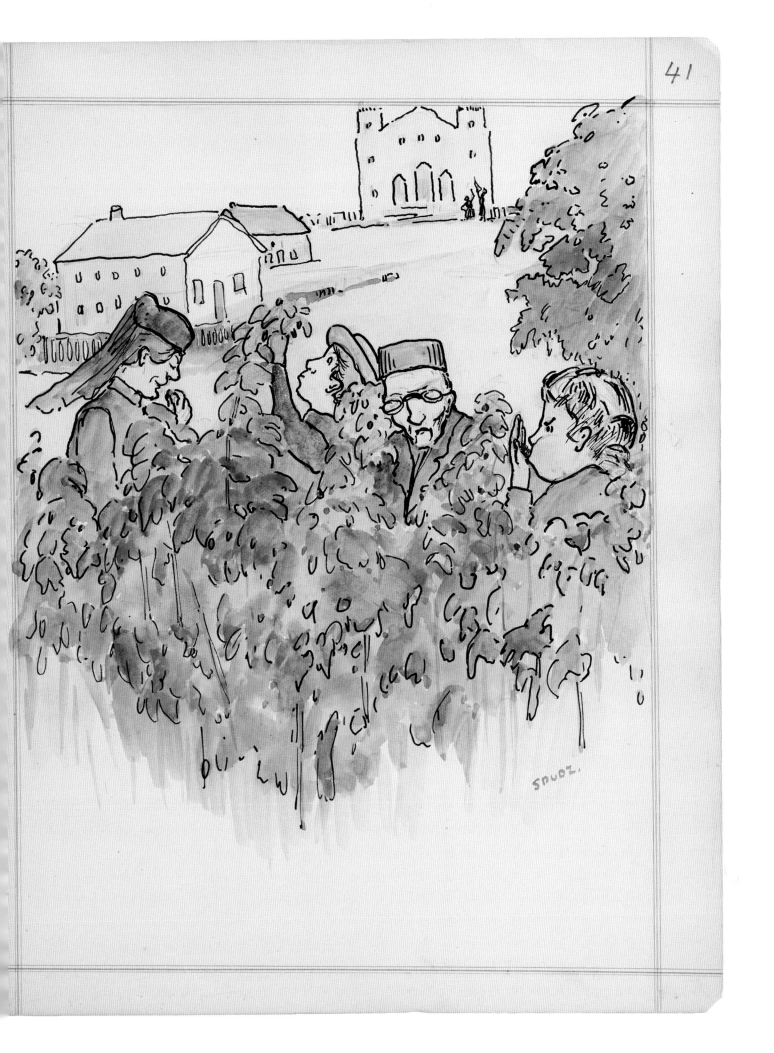

WE NOW ARRIVED AT ONE OF THOSE ABHORRENT
OPEN SEA PASSAGES, WHERE 'DEATH IS PREFFERABLE
TO LIFE' AND TO "PASS AWAY WERE VNUTTERABLE BLISS,"
FOR TWO DAYS MY VEIW WAS RESTRICTED TO ~~SISTERS~~
SISTER'S BED SPRINGS. AND I ENDURED MENTAL,
AND BODILY ANGUISH, IN A SUPERLATIVE DEGREE, SISTER'S
ANGUISH WAS BUT A MENTAL REFLECTION OF MY OWN;
SHE LINGERED LONG ON DECK, AND **KEPT CAREFULLY OUT OF THE**
RANG OF BOOTS AND ODDMENTS, WHEN SOLICITING ENQUIRIES AS
TO MY HEALTH; WITH SMOOTH WATER SERENITY, AND
APPETITE <u>WOULD</u> HAVE RETURNED, SAVE THAT THEY NE-
GLECTED TO BRING ME <u>FOOD</u>, WHEREAT <u>MIGHTY</u> WAS
MY WRATH: REGRETTING THE NEGLECT, THE HEAD STEWARD
STROVE TO PERSUADE ONE OF HIS SUBORDINATES. TO BRING
UP A TRAY; BUT IN TERROR THEY FLED TO THE
RIGGING WHILE SISTER <u>WEAKLY WEPT</u>, AND IN INDIGNAN
WRATH I DRESSED AND DESCENDED TO THE SALOON,
WHERE AFTER DISPOSING OF A LARGE MEAL. I EXCEPT
THE HEAD STEWARDS APOLOGIES, AND SO FAR FORGAVE
HIS SUBORDINATES, THAT THEY DEIGNED NEXT
DAY TO ACCEPT MY PROFFERED TIPS WHEN
ARRIVING IN PORT.

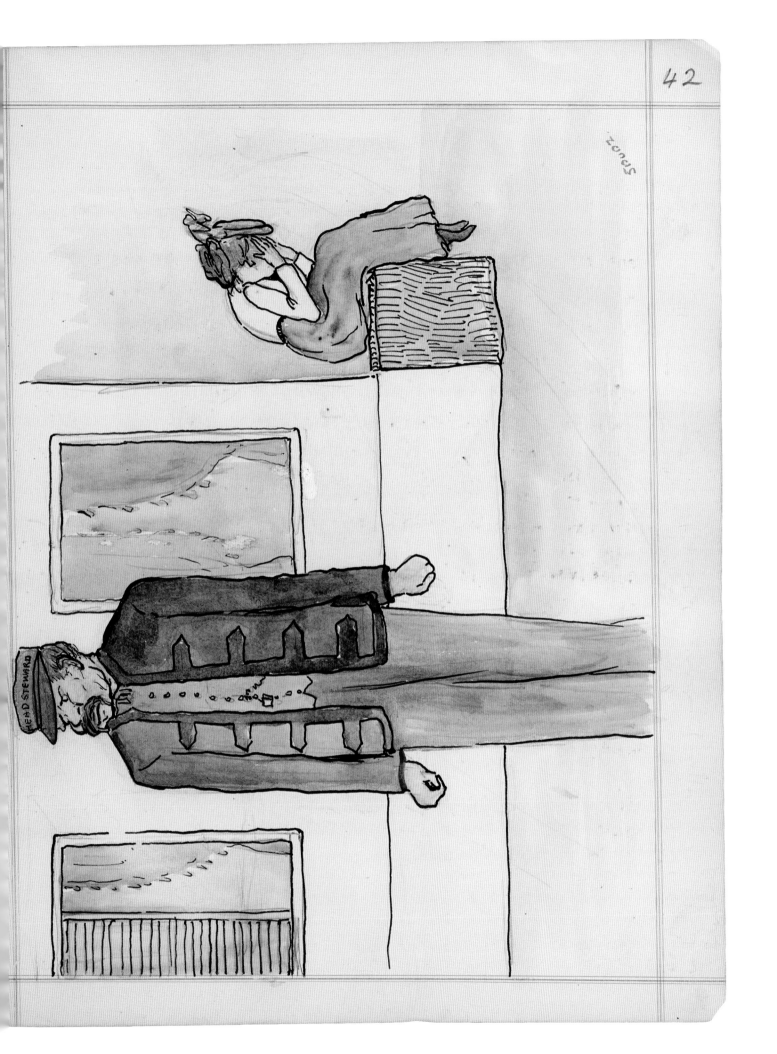

WE STOPPED FOR THREE HOT DIRTY HOURS
IN NANAINO COALING, WHICH TIME WAS MAINLY
OCCUPIED IN EXTRACTING CINDERS FROM EACH
OTHER'S EYES.

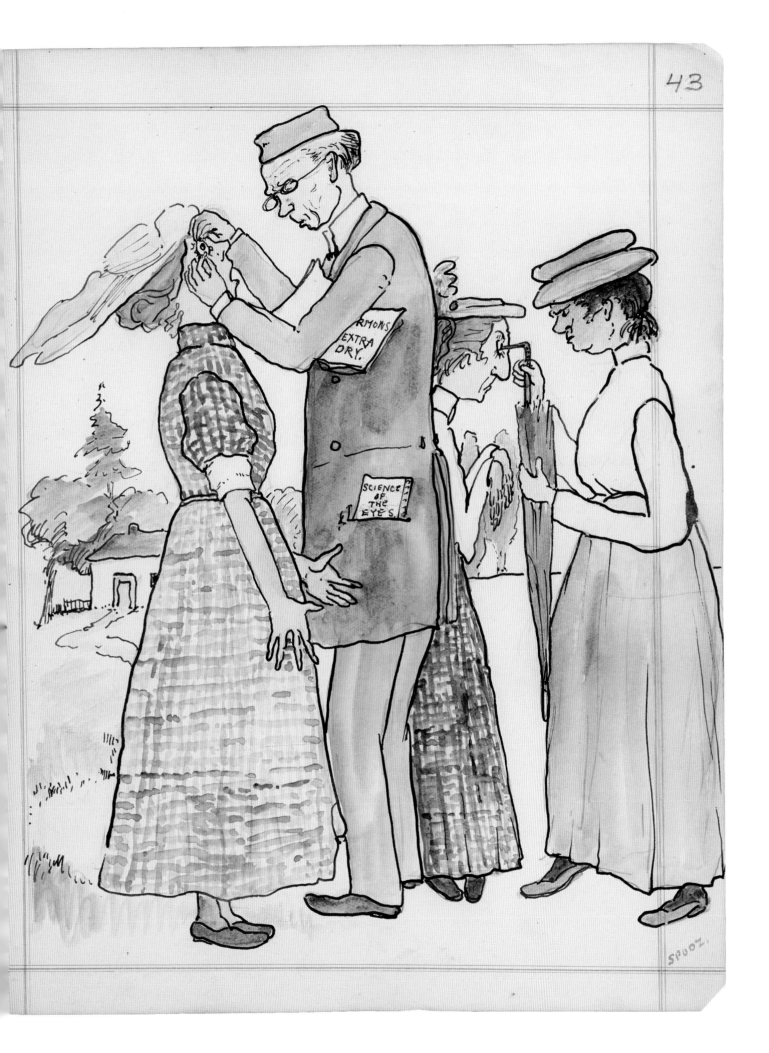

ARRIVING IN SEATTLE WE TIPPED OUR TIPS
AND STEPPED GRACEFUFFY FROM THE DOLPHIN
TO THE CHIPPEWA 'EN ROUT' FOR HOME.

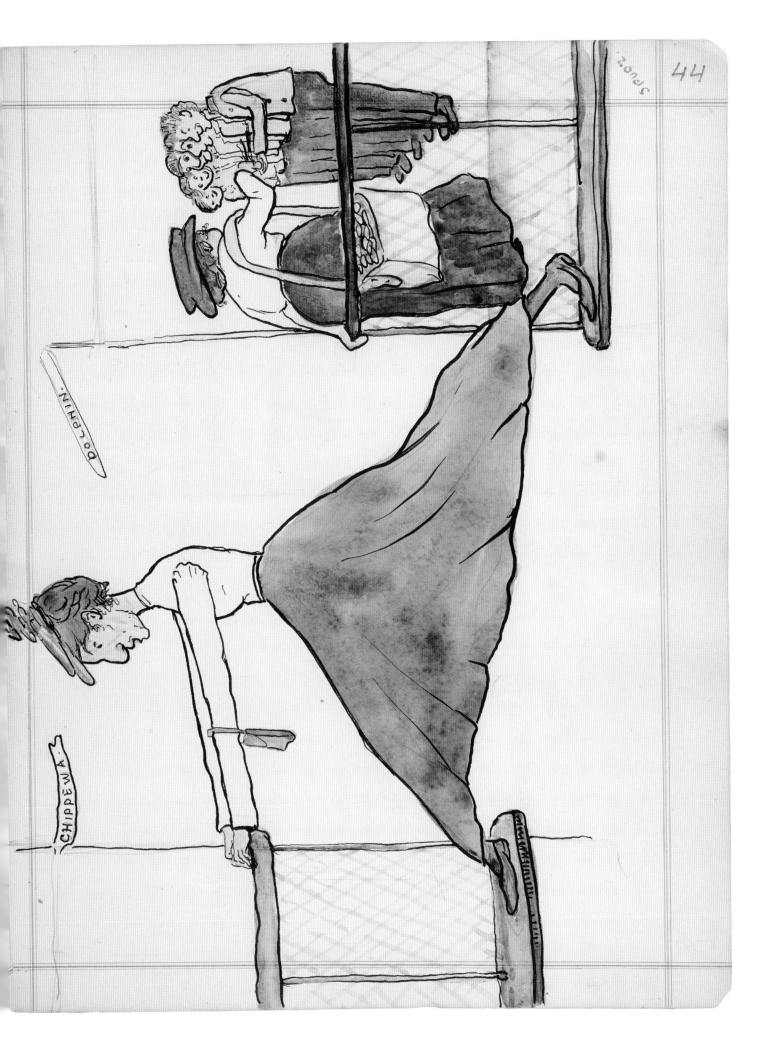

IT WAS AT THIS JUNCTURE THAT SISTER MET ME WITH A RADIENT COUNTENANCE, SAYING "I EVEN I HAVE PREVAILED UPON A RUFFIANLY LOOKING MAN FOR A CONSIDERABLE PRICE TO TAKE THE LUGGAGE" BUT WHEN I ASKED TO WHERE? SHE DID NOT KNOW.

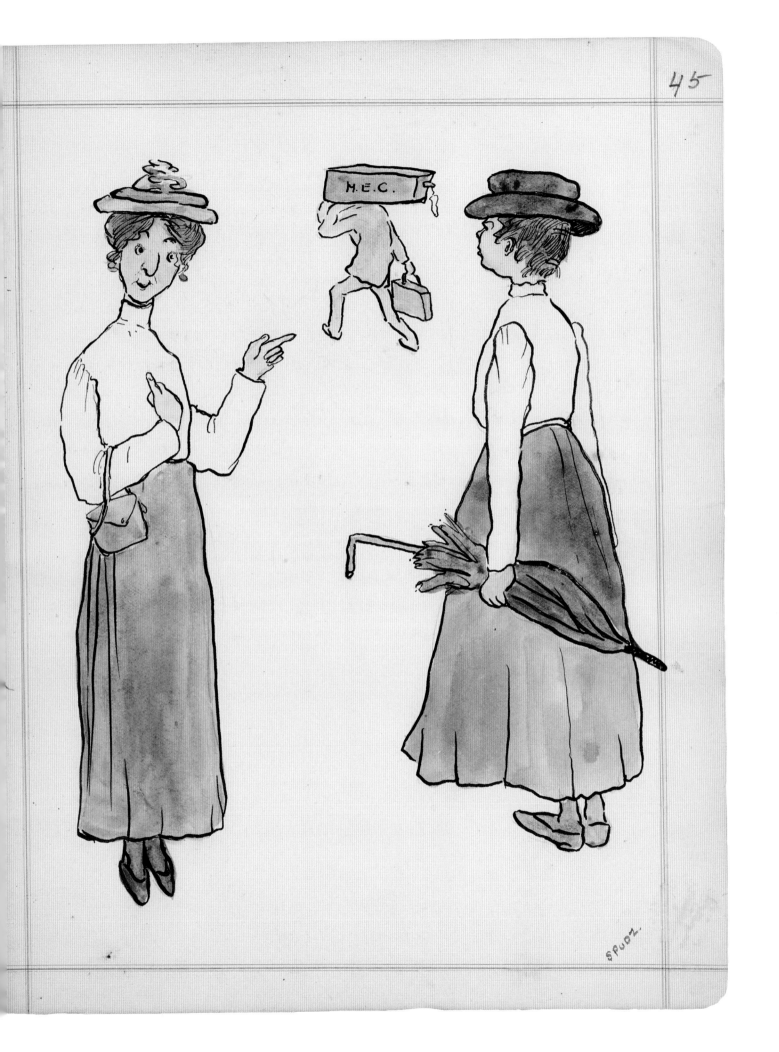

THO' CRUELLY HARRASSED BY THE LOSS OF OUR
LUGGAGE; I WAS OBLIGED TO PRESENT A JAUNTY
AND UNCONCERNED EXTERIOR, LEST APPARENT ANXIETY
SHOULD EXCITE THE SUSPICION OF THE AUSTERE OFFICIAL
OF THE CUSTOMS: WHO WATCHED US DESCEND THE
GANG-PLANK. PAINFULLY CONSCIOUS THE WHILE
OF THE BRAN NEW BOOTS UPON MY FEET AND THE
DEER HIDE IN MY SHAWL STRAP, (BOTH HIGHLY DUTIABLE
ARTICLES) SISTER WAS TOTALLY CRUSHED, NOT SO
MUCH BY THE LOSS OF HER SUITCASE, AS THE
CONDITION OF HER CHERISHED RED PARASOL, THE
STEWARD HAVING BROKEN THE CHOICE GREEN DOG
COMPOSING ITS HANDLE, AND TORN ITS GORGEOUS
SILK SIDE.

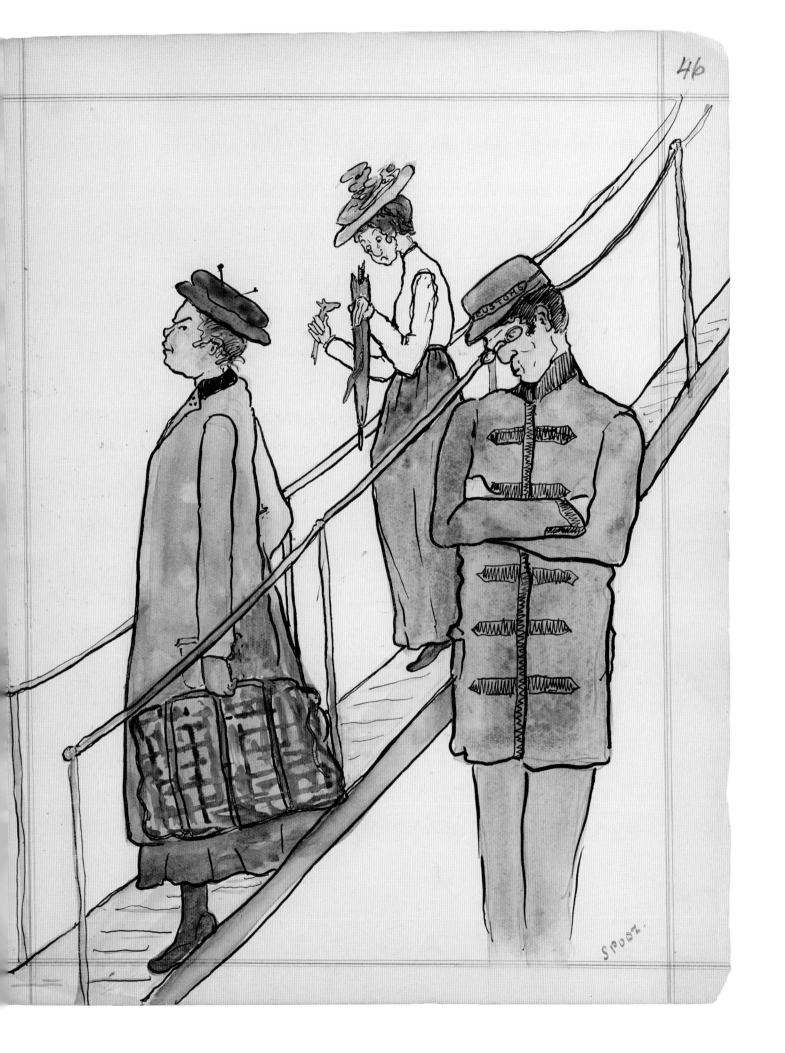

IT WAS HUMBLING TO MEET OUR FRIENDS EMPTY
HANDED., BUT AFTER TWO DAYS CONSTANT
IRRITATION OF THE OFFICIALS. OUR LUGGAGE
WAS UNEARTHED.
HAVING THE UTMOST CONTEMPT OF A'' EXPRESS Co's
AND VAN SOCIETIES; WE DETERMINED ON NO
ACCOUNT TO AGAIN LET IT OUT OF OUR SIGHT,
AND ACCEPTED WITH GRATITUDE ~~THE~~ A GOOD
FRIEND'S
~~KAISERS~~ OFFER OF HER VENERABLE HORSE
AND CHAISE, AND THUS PERSONALLY
CONDUCTED IT HOME.

THUS ENDED OUR ALASKAN TRIP LEAVING
US.
 A LITTLE OLDER
 A LITTLE HEALTHIER
 A LITTLE WISER.

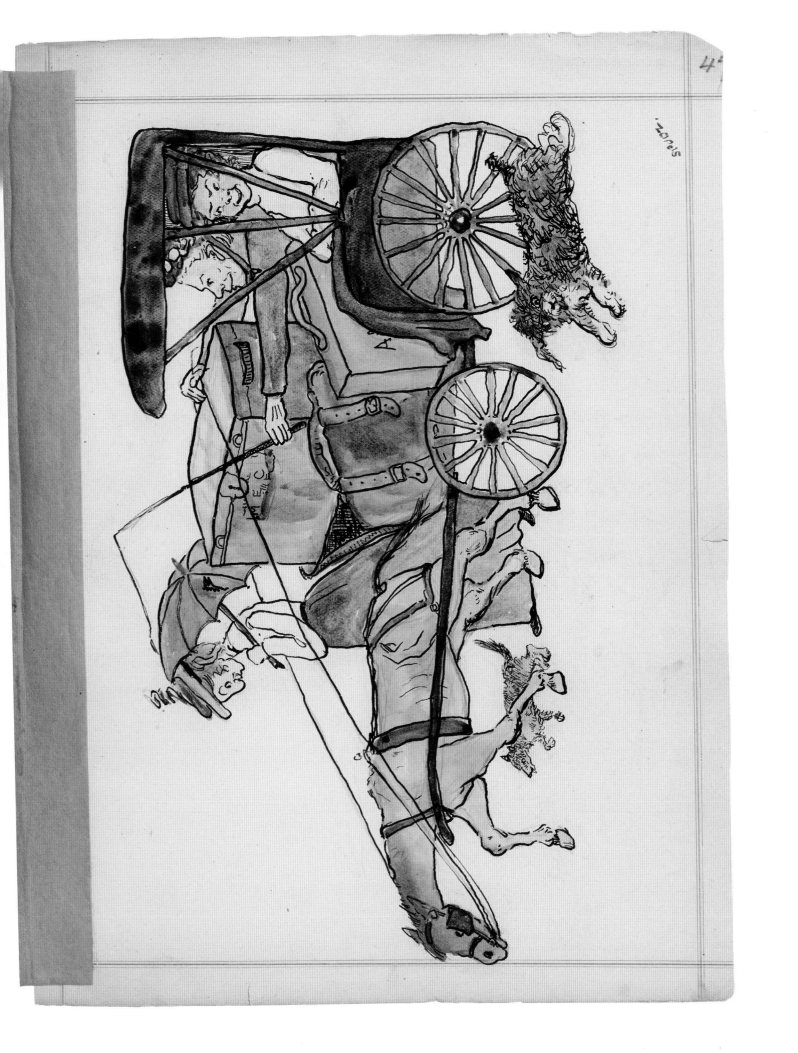

CANADIAN PACIFIC HOTELS

EMPRESS HOTEL
VICTORIA, B.C.

Actually at Klitsa
Lodge
Sproat Lake
near Port Alberni
Vancouver Island,
Sept 10/47.

Dearest Family,

This is beginning at the wrong
end, but I must not wait till the
event dims before I record it. The
event, of course, is my visit to Alice
Carr's at 220 St. Andrews St.

I was to be in Victoria only
two days, of which the first was com-
pletely taken up, + the second rather full.
So I phoned Miss Alice as soon as

Actually at Klitsa Lodge
Sprout Lake
near Port Alberni
Vancouver Island,
Sept 10/47

DEAREST FAMILY,
This is beginning at the wrong end, but I must not wait till the event dims before I record it. The event, of course, is my visit to Alice Carr's at 220 St. Andrews St.

I was to be in Victoria only two days, of which the first was completely taken up, & the second rather full. So I phoned Miss Alice as soon as I was able to on arrival, & we arranged that I should come to see her during yesterday evening.

It occurred to me that I should take her a little present, as from mother, and the only thing I could think of was a nice cup and saucer, since I was sure she must drink considerable tea! So I set out one lunch time in quest of my present, & found some lively ones, only to discover that I couldn't get one without buying a whole set! The single ones were sparse and poorish. So I hunted & hunted and had no luck, at china shops (one was closed because it had had a fire the night before), at silversmiths, at novelty & gift shops. Finally at the Hudson Bay Store I found a table of odd cups & saucers, and saw one that I liked. It turned out to be Minton (turquoise & gold pattern). I had asked the lady in Wedgewood's what shape she would recommend for an elderly lady, & she suggested a tallish cup, rather than a wide shallow type, as the tea would stay hot longer in it. This Minton cup filled all the bills, so I had it wrapped carefully inside the box, & gift-wrapped outside (white tissue paper, & green cellophane ribbon—all they had).

That evening I had to attend a dinner that Ross [Ross McLean, Government Film Commissioner, head of the National Film Board] was giving for local dignitaries. The Provincial Minister of Forests was there, his worship Mayor George of Victoria, various municipal reeves, Editors of local papers, Temporary President of the Chamber of Commerce (Major Cuthbert Holmes), trade union representatives, etc. etc. I discovered that the thing was going to go on for some considerable time, & I couldn't very well leave while the toastmaster was introducing the Minister,

the Major or other gentlemen, or while they were speaking, or while Ross was making his address, or while the dignitaries were making their immediate queries. As soon as I could leave, I found it was 10 pm! I phoned Miss Alice again, & asked if was too late to come, & she said "Not unless it's too late for you! We were just giving you up for lost, and are drinking your coffee." So I went by Taxi, as soon as I had collected my parcel.

It was quite dark when I arrived, but the number 220 was clear under a street light. A path went past the frame house toward the back, & I found myself knocking on a kitchen door. After a little pause, the door was opened by a little old lady, & it was Alice Carr. She welcomed me in, asked me to take off my coat & make myself comfortable, and introduced me to Miss Wilson, her day-time companion. (Miss Alice does not like to go outside the house alone. She is 78 now, and mostly blind and quite deaf. But one eye was much improved by the operation 2 years ago, & can see enough to appreciate Emily's paintings when she is not tired, and even to read a little.)

I presented my parcel, & Miss Alice was evidently pleased and even a little excited. She said she did so like to get presents & couldn't wait to open it. She had a little difficulty finding the outer wrapper opening, then found her way through to the box, opened it, and began to feel the contents & unwrap them. Miss Wilson thought it might be a cup & saucer; she herself wasn't sure, & then—yes, she was. She seemed visibly pleased & looked at it from all sides through her small but strong glasses. She asked me if it was green or blue; she could see the gold, but wasn't sure of the color. I explained it was both, being turquoise.

She put it on the table, and then got Miss Wilson to get me a cup of coffee and some cake, served with a plate and linen napkin. Miss Alice is very quick, & quite spry, and really very cheery. She was completely appreciative of every nicety. Her main regret is that life is so short, and it takes so long to do anything perfectly. But we agreed that if we perfected everything in this life there would be no point in anything else. Her main love is music, more than painting — she thinks it is of a higher order, & laughingly told me of the music-lover across the street who sings flat.

But, she said, I must see her [Emily's] pictures (some of which I was already eyeing, whenever I could). She only had two of her recent paintings, she said. And

they were both in her small "living" room—next the kitchen—where we were sitting, enjoying a bright fire in a small corner grate. One was a seascape, with more land in the foreground than in ours, and not so impressive, with more yellows in it, and less atmospheric reality. The other, however, is a superb forest study, with all kinds of trees, tall ones at the left end, squat ones at the bottom, and pines & firs done with a variety of sure techniques, including one which looked exactly like the latest period counter-part of Mother's "corkscrew" trees in the left side of the Eagle Totem picture. The picture was full of atmosphere, soft, and with lovely greys in it, as well as greens, browns, mauves, & blues. It is as good of <u>its</u> kind as I have seen: "The trees seem actually to move, don't they?" said Alice.

The other pictures in the room were more to Alice's taste, and there were 3 large watercolors of the family garden — all done in 1909 (same year as our young girl one in mother's room). One was of Lombardy poplars, lofty & a lovely windy green, but subdued in the old-fashioned way. Another was looking down through a lane to a fence or gate beyond in a vista. The third was of 4 sisters in the garden, including Emily in the background (with two parrots!). Billy, (the dog) is sitting under the table, spread with a tablecloth for a picnic in the garden. (That one is a very charming one & a fine record). There were other smaller ones of flowers & garden nooks.

Elsewhere around the walls were photos—of Emily, of nephews & nieces, and others. And then a lovely watercolor just above & beside where she was sitting near the fire—of an arbutus tree. A very lovely one, quite small & full of feeling. It also was quite early, but I'm not sure of the date.

We talked some more, & had more coffee, and then she took me to see the pictures in the kitchen. There were more garden ones, though none that impressed me so much. But there was a picture of Alice seated at a table that I recognized from the red hair, and the likeness to the Clarkes' picture of the 2 of them in England or France. (Alice thought that our picture of the girl with red hair might be herself—except for the age discrepancy). The kitchen also had two fine oil sketches from France, the best of them being a study of some small boats in the water, perhaps in a canal. They were strong, more colorful, tending to blues, greens, & purples. There was also a rather naive, but cute, study of a brown dog, face on—rough, & a bit crude. But the *pièce de résistance* was the actual portrait of

"Billy" himself, hanging on the wall beside the door. It is the one in the frontispiece of the *House of All Sorts*. It is dated 1909.

We sat down again in the living room, & chatted about many things. I told her how much Emily had meant & still meant to all of us. She told me about her nephews & nieces (whose names are on the back of her various pictures. They are to get them—after she dies.). None of her relatives live in Victoria now. They have all gone to Vancouver & elsewhere.

After a little while she disappeared for a bit, & came back with a sort of scribbler, marked on the outside: "Sister & I in Alaska." It was a sort of play by play account of their trip together to Alaska in 1907, with written paragraphs printed on the left hand side, and a cartoon drawn & colored on the right. The cartoons were very funny, & spared neither Alice nor Emily in their humor or observation. All sorts of events were heightened, like the weak bed springs & the seasickness at sea, the hiking & mountain climbing in Alaska near Skagway, getting lost in the woods etc, & comments on people who go everywhere with Kodaks & take pictures mostly of themselves. All the cartoons were signed "SPUDZ" — her own nickname at that time for herself, according to Alice — as was also a little poem on the wall, framed with a profile drawing of Billy, entitled "Bill", & to the effect that the only person who ever cared about her, understood her, or comforted her, was Billy. But, to return to the Alaska trip, I read it aloud, & we all laughed, I over my first sight of each cartoon, Alice over her memory of them. Alice's red hair was much in evidence, & the different characters of the two of them. Alice tallish, lissome, optimistic, prepared, and proper & serene; Emily squat, bundled, muddy, and unconcerned with how she expressed her feelings. Many were terribly funny, like the one of them riding horses side saddle, in profile, while everything else (men & horses) are seen strictly back view. The spelling also was atrocious & funny—some words spelt like they sound; others just wrong! One of the funniest looking was a solid presentation of the word bug, at just the right moment, spelt BUGG. Perhaps one of the most interesting pages shows a bunch of people looking at a totem pole, colored, which may well be Emily's first picture of a totem pole in existence, as Alice thought that Emily didn't meet the B.C. Indians till 2 or 3 years later (which may well be, since I've heard of no such picture till perhaps 1908 at the earliest).

CANADIAN PACIFIC HOTELS

EMPRESS HOTEL
VICTORIA, B.C.

much Emily had meant & still
meant to all of us. She told me
about her nephews & nieces (whose
names are on the back of her
various pictures. They are to get
them — after she dies.). None
of her relatives live in Victoria now.
They have all gone to Vancouver &
elsewhere.

After a little while she disappeared
for a bit, & came back with a sort
of scribbler, marked on the outside:
" Sister & I in Alaska." It was a
sort of play by play account of their
trip together to Alaska in 1907, with

written paragraphs printed on the
left hand side, and a cartoon
drawn & colored on the right.
The cartoons were very funny, &
spared neither Alice nor Emily in
their humor or observation. All
sorts of events were heightened,
like the weak bed springs &
the seasickness at sea, the
hiking & mountain climbing in Alaska, near Skagway
getting lost in the woods etc., & comments
on people who go everywhere with
kodaks & take pictures mostly of
themselves. All the cartoons were
signed "SPUDZ" — her own nick-
name at that time for herself,
according to Alice — as was also
a little poem on the wall, framed
with a profile drawing of Billy, entitled
"Bill", & to the effect that the only

Alice mentioned another such chap book on their trip to Paris, which she says is even funnier. But Ira Dilworth has this, which rather annoys Alice, as she feels it should really belong to her.

Presently, Alice asked me if I'd like to see Milly's studio. Which, naturally, yes! So we went up a step or two into a little passage, off the entrance to the kitchen, opening into a large cool room, which had been the studio, at the back of the house. Alice had originally built it, with a large fire place, as a schoolroom for her pupils. (She taught school for 40 years). Later Emily used it for her studio. It runs the full width of the house, which has now been divided into 2 sections; Alice living in one, & deriving rent from the other half. So we were quieter in the studio than we had been elsewhere. There are one or two pictures still on the walls, mostly other early watercolors of flowers & the garden, again. More interesting were the changes Emily had made, such as not having the fire, but putting in a stove right in front of it & using the same chimney. "More economical," said Alice. "It only uses half as much fuel. But I rather like a fire place." (She keeps the brass fender shone even now, & the room dusted. She complained that it never will keep free of dust. I tried to find a copy of Emerson on the dusty shelves but apparently, if that book of Emerson's on "How to look at Modern Pictures" exists, Ira Dilworth must have it.)

The sort of improvisation Emily made is shown by the way she got a standard lamp out of her way by sticking the bottom of it high up against a wall, & hanging it out from the wall with a piece of thick string. It's still that way. It gives light, without getting in your way.

Alice told me she was <u>always</u> doing something, there were some of her hooked rugs on the floor. She said that she mended, & sewed, & cooked, & repaired things all the time. People used to say that if there weren't holes in things, she'd cut holes in them, just so she could mend them. She used to put very hot things in the bed to keep her warm, which would scorch the sheets. And then she'd patch them. But once, the bedding caught fire!

And then we went to a big desk with shelves & drawers, & found a number of pieces of her pottery. There were other pieces on a shelf by the fire, and two special ones that Alice drew out of a drawer from between pieces of linen and clothing, to keep them from breaking. They were all, of course, based on Indian

person who ever cared about her, understood her, or comforted her, was Billy. But, to return to the Alaska trip, ~~it~~ I read it aloud, & we all laughed, I over my first sight of each cartoon, Alice over her memory of them. Alice's red hair was much in evidence, & the different characters of the two of them. Alice tallish, lissome, optimistic, prepared, and proper & serene; Emily squat, bundled, muddy, and unconcerned with how she expressed her feelings. Many were terribly funny, like the one of them riding horses side saddle, in profile, while everything else (men & horses) are seen strictly back view. The spelling also was atrocious & funny — some words spelt like they sound; others just wrong! One of the funniest looking was a solid presentation of the word bug, at just the right moment, spelt BUGG. Perhaps one of the most interesting pages shows a bunch of people looking at a totem pole, colored, which may well be ~~the~~ Emily's first picture of a totem pole in existence, ~~but~~ as Alice thought that Emily didn't meet the B.C. Indians till 2 or 3 years later. (which may well be, since I've heard of no such picture till perhaps 1908 at the earliest).

Alice mentioned another such ~~chap-book~~ on their trip to Paris, which she says is even funnier. But Ira Dilworth has his,

which rather annoys Alice, as she
feels it should really belong to her.

Presently, Alice asked me
if I'd like to see Milly's
studio. Which, naturally, yes!
So we went up a step or two into
a little passage, off the entrance
to the kitchen, opening into a large
cool room, which had been the
studio, at the back of the house. Alice
had originally built it, with a
large fire place, as a schoolroom
for her pupils. (She taught school
for 40 years). Later Emily used
it for her studio. It runs the full
width of the house, which has now

designs—& all signed "Klee Wyck", either by scratching it into the clay, or painting it on with the design. There were various kinds of objects, from bowls & plates, to a fine plaque, & many smaller objects, little pitchers, match holders, & even little flat decorative pieces of various designs. The Art Gallery has asked that the best pieces be saved for the new wing of the Art Gallery, but Alice despairs of it getting built, & complains of the impossibility of getting materials to build the little memorial bridge over a stream in Beacon Hill Park where they used to wheel Emily 2 or 3 times a day in her wheel-chair.

Then Alice said she thought it would be all right if I took one of the smaller pieces of pottery along for mother. She told me to choose any one I wanted. But I asked her if she wouldn't choose herself, as I thought she would be a better judge of what she would specially like mother to have. So she picked a nice little pitcher, which I will not describe, but which is very lovely. And then she pushed over a match-holder (which I will not describe either)—for me! It was really most touching. And I felt that she really felt we were good friends.

As we left the studio, I noticed three old broken, & much used, wooden dolls, hanging over the fire place. They had been Emily's.

Just before I left (she said I could stay as late as I pleased, & she wanted to be sure I got all my questions answered), we went to look in the bedroom. There were <u>more</u> Emilys here: the first that caught my eye was a watercolor of a Breton girl standing in a door—quite a nice one of the French period. There were some other, "discarded" (by the Trust) French sketches, including one of washerwomen, another of a poppy field (the latter quite nice), they weren't as fine as others I've seen. There were two others, very early—a study of roses, which is being given to a Major Holmes who has 34 of her paintings, in town,—& a drawing in black & white which she "did up" from a tiny photograph of a girl in profile. It's well done, but very photographic.

As I was leaving, with Miss Wilson, she showed me her braille typewriter, & how it works. It's very simple, & sensible. Alice still "goes by touch more than by sight," she says.

We made our goodbyes & left the cheery house with its fireplaces everywhere, by the kitchen again, avoiding the lame cat on the porch which "doesn't like men" & spat at us. Miss Wilson then showed me how to walk down to the hotel again,

but first took me to see the other memories nearby: round the corner of the block to the House of All Sorts, which is still essentially the same inside, but stuccoed over on the lower half outside. It is still an apartment house. We could see the attic window by street light.

Just beyond, Miss Wilson showed me where the "lily field" had been, though it had once stretched longer toward the harbor than now. A number of trees grow in it, but by night light & moon, the weeds <u>might</u> have been lily plants to the uninitiated.

Then we went round to what was once "Carr" St, (now "Government Street") where the old family home is. It is now a rooming house, & the old carriage drive in front of it looks dilapidated even at night. There was a light shining through heavy lace curtains in the twin lace windows of the upper landing.

Miss Wilson lives just across the street, in 2 rooms. Like the Carrs, her family had lost their money. It's a sad story of taxes, which ultimately swallowed up all the land. At one point the Carrs gave some land to the city; the city put a road through; the land became desirable; & the taxes went up <u>again</u>! There are now many private houses on the original property.

After saying goodnight to Miss Wilson, I walked home, hardly seeing anything but the evening behind me, with my little pottery pieces, wrapped in the same box & tissue paper I had brought the cup & saucer in, under my arm.

And so I went to bed, after writing the notes for this letter. And so I must go to bed now.

Sometime I will complete the story of the rest of the trip!

Much love, & you'll
have to wait till
I get back to see
the pottery!

Tom.

nor many private houses on the original property.

After saying goodnight to Mrs Wilson, I walked home, hardly seeing anything but the evening behind me, with my little pottery pieces, wrapped in the same box & tissue paper I had brought the cup & saucer in, under my arm.

And so I went to bed, after writing the notes for this letter. And so I must go to bed now.

Sometime I will complete the story of the rest of the trip!

Much love, & you'll have to wait till I get back to see the pottery!

Tom.

Acknowledgements

THE DALY FAMILY generously encouraged this limited edition facsimile of Emily Carr's diary made for her sister Alice, with whom she travelled to Alaska in 1907. They described the relationship between the Dalys and first Emily and then Alice Carr, which led to the diary coming into their possession in 1953. They also provided some financial support at the outset, attentively read through and corrected the long letter written by Tom Daly in 1947, and made useful suggestions about the Introduction.

Tom Daly (1918–2011) went directly to the National Film Board from graduation at the University of Toronto in 1940 and became one of its most innovative and creative forces as an editor, a director, and a producer over a period of forty years. The first film he worked on, *Churchill's Island* (for which he was the assistant to editor Stuart Legg), won an Oscar. Daly set up and oversaw Unit B, which produced over three hundred films, many of them award-winning and all contributing significantly to the art of the documentary film. He was a key editor of *Labyrinthe*, the spectacular multiscreen film at Expo 67. His contribution to the art of film in Canada was both major and brilliant.

Rod Green of Masters Gallery in Calgary gave financial support and sound advice on the marketing of this book.

Kathryn Bridge in the Archives at the Royal British Columbia Museum, Victoria, and her colleage Don Bourdon, helpfully provided access to the two 1907 watercolours by Emily Carr reproduced in the Introduction. Their colleague Martha Black also assisted with information and other contacts. Of course Ms. Bridge's Introduction in her publication of the *Victoria to London* diary was a great assistance and model for me as well.

Michael Cullen of Trent Photographics expertly shot the digital colour images of the diary itself, and also provided us with a useful iPad version, which allowed us to flip pages easily to show curators and others the diary, which is now, at 106 years of age, quite fragile. Richard-Max Tremblay photographed the Tom Daly letter. Diane Hargrave provided her usual sage advice on publicity and promotion matters.

All of us involved in preparing this diary for publication are indebted to the expert team at Figure 1 Publishing: Chris Labonté, Peter Cocking, and Richard Nadeau.

DAVID P. SILCOX

DAVID P. SILCOX has received the Order of Canada and a Governor General's Award for his many contributions to all the disciplines of the arts in Canada. He has written several award-winning books: *Painting Place: the Life and Work of David B. Milne; Tom Thomson: The Silence and The Storm* (with Harold Town); *The Group of Seven and Tom Thomson;* and *Christopher Pratt;* as well as numerous articles, catalogues, and reviews on artists and the arts.

First trade edition 2014

The diary copyright © 2013 The Daly family
Introduction copyright © 2013 by DSLI Limited
Images on pages iv, 2, 7, and 12 provided courtesy
of the Royal British Columbia Museum © 2013, 2014

15 16 17 18 5 4 3 2

Cataloguing data available from Library and Archives Canada
ISBN 978-1-927958-01-8 (hbk.)

Cover design by Peter Cocking
Interior design by Naomi MacDougall
Printed and bound in China by 1010 Printing Group Ltd.
Distributed in the U.S. by Publisher's Group West

Figure 1 Publishing
Vancouver BC Canada
www.figure1pub.com

NOTE: The diary is old and fragile and at some point the cover split in two, since the rear cover is glued, with the pieces of tape, to the front cover, upside down. The embossed lettering, MAPPING BOOK, is as printed: backwards, as if seen in a mirror.